HIDDEN
HISTORY
of
SONOMA
COUNTY

HIDDEN
HISTORY
of
SONOMA
COUNTY

John C. Schubert, with Valerie A. Munthe

THE
History
PRESS

Published by The History Press
Charleston, SC
www.historypress.net

Front cover: Downtown Santa Rosa, 1895. The Methodist Episcopal Church at the upper left stood on the southeast corner of D and Third Streets. Third Street continues west past the Grand Hotel at the lower right. The picture was taken from the top of the old courthouse. *Courtesy Don Silverek Collection.*
Back cover, top: Autos in Guerneville, circa 1912. *Left to right*: an EMF, a Franklin and a Pierce. *Courtesy of John C. Schubert Collection; bottom*: Pomo man dressed in dance regalia, with red headband and feather adornments. *From John C. Schubert's* Guerneville Early Days, *courtesy of Hearst Museum at University of California–Berkeley.*

First published 2017

Manufactured in the United States

ISBN 9781467138277

Library of Congress Control Number: 2017948493

Notice: The information in this book is true and complete to the best of our knowledge. It is offered without guarantee on the part of the authors or The History Press. The authors and The History Press disclaim all liability in connection with the use of this book.

John: To my grandchildren: Jasmine, Sabrina, Johnna, Heather and Doran.

Valerie: To all the women writers and recorders of history who have inspired me to take up the pen and make my voice relevant. Dedicated also to my three children, Atreyu, Jadziah and Stella, without whom my motivation would be entirely self-serving. And last, but certainly far from least, my best friend and husband, Jesse, for his dedication to our family and his support of my dreams.

CONTENTS

ACKNOWLEDGEMENTS

The authors would like to extend their gratitude to the following organizations for contributions to the stories herein:
State of California:
 Armstrong Redwoods State Natural Reserve (Sonoma County)
 Railroad Museum and Archives (Sacramento)
 California Department of Transportation
 Maritime Museum (San Francisco)
Sonoma County Offices of:
 Sheriff
 Board of Supervisors
 County Clerk
 County Recorder
 Transportation
 Law Library
Historical Societies of
 Healdsburg and Museum
 Sonoma County
 Russian River
Northwestern Pacific Railroad
Eugene Public Library

John: Without support and indulgence by family and friends, I wouldn't be able to chase the demons of history, capture them and "pen" them down on

paper. And there have been many that have helped in this endeavor over the decades. First and foremost has been Sarah, who has traveled through the decades with me in pursuit of many stories throughout California and then some. She has proofread many of these histories and helped direct me in my writings. Secondly have been fellow historians in their own right: Valerie Munthe, Jane Barry, Glen Burch, David W. Perry, C. Raymond Clar, Clare Harris and Charlie Siebenthal. The following people have also contributed greatly to these pursuits: Jack Hetzel, Alta Luttrell, Tony Hoskins, Katherine Rinehart, Joan Guillaumin—my deepest appreciation and thanks to you all. A special acknowledgement and thank-you goes to Valerie Munthe, who shepherded me through her editing, photo work and the electronic maze of today's modern technology.

Valerie: Acknowledgement on my behalf is owed to those who allowed me time and space to ignore their needs so I might work, including my family, friends and colleagues. A special acknowledgement to Sarah Brooks for her tenacious proofreading skills and allowing me to hijack John's attention. Also credit is due to my darling husband, Jesse, and older children, Atreyu and Jadziah, for dutifully caring for our infant daughter, Stella, so that "Mommy can work." And last but not least, to John Schubert, without whom the opportunity to write historical manuscripts would be made a lot more difficult and far less entertaining.

INTRODUCTION

When John approached me some years ago with yet another manuscript, I did not realize then how much my own voice would be involved in its creation. Over the span of forty years, John compiled data and composed these twelve stories. Throughout our professional relationship, I have often teased him about his staccato style of writing—facts, lightly adorned narratives, sprinkled in here and there. However, given the nature of historical writings, I worried that the attention span of his reader would suffer; that's where I came in. Armed with witty rhetoric and a storyteller's voice, I took up the challenge of putting color to the black-and-white scenes of Sonoma County's past. Within a year, the combination of his hard work and my editorial skills transformed these stories, laden with academic prose, into the body of work presented within these pages.

Our previous publication, *Stumptown Stories: Tales of the Russian River*, was created in a very similar fashion; he wrote the original stories, I typed them from photocopies of newspaper clippings and compiled them, along with relevant images, into a cohesive manuscript. It was cut and dry. However, this collection that you are about to read was a completely different experience. Instead of featuring a character like the "Ol' Timer" of *Stumptown Stories*, each story stood as separate chronicles of the past, being more academic in nature. Each required hours of research, writing, editing and illustrating in order to bring to life this precious history.

What makes this book so unique to the others? Each story presents a perspective of Sonoma County that, I'm certain, inquiring minds have,

at some point in life, pondered about. Why is Bodega Bay named so? How did our Sheriff's Office develop? What is the relevance of Old West lawlessness to Sonoma County? In his usual fashion, John set out to answer these questions, some stories taking years to gather sufficient facts and data that would eventually morph into articles. However, these stories, although celebrated among the history enthusiasts of the county, sat for many years unnoticed by the public at large.

Reading in chronological order, these hidden histories begin with Captain Bodega y Quadra and the earliest known explorations of Sonoma County and the Pacific coastline. Then, taking to the valleys of Santa Rosa and Healdsburg, you'll learn about the Pomo, the Miwok and the Wappo natives and their interactions with European explorers. Fort Ross makes its appearance as we examine what life was like during a time of assimilation for the Kashaya Pomo. Read further about a wave of crime that hit northern Sonoma County in "Stand and Deliver!," award-winning tobacco cultivated in Cloverdale, a mob taking the law into its own hands, houses of ill fame in Santa Rosa's downtown neighborhood, the rise of the automobile and so much more.

We invite you, the reader and fellow history enthusiast, to explore the hidden histories of Northern California's Sonoma County.

—Valerie Munthe

Chapter 1

A Journey of Discovery

The Story of Bodega y Quadra

This story was awarded the Editor's Award in December 1988 by the Sonoma County Historical Society.

In western Sonoma County, the name Bodega occurs in many locations, the most well known of which is Bodega Bay, a small coastal village located just ten miles south of the mouth of the Russian River. This small community has, over the years, become the seaside attraction of Sonoma County, complete with its harbor, hiking trails and beautiful landscape. But how did it become "Bodega Bay"? Spanish for "wine cellar," this small inlet of sea water was named in honor of its discoverer, Spanish naval officer and Peruvian native Don Juan Francisco de la Bodega y Quadra.

Bodega y Quadra was born in Lima, Peru, in 1744. His parents were Spanish nobility of Basque origin. His father, Tomas de la Bodega y de las Llamas, was an *alcalde* (mayor) in absentia of Somorrostro Valley in northern Spain and a minor noble of Vizcaya. Little is known of his mother aside from her name, Francisca de Millinedo y Losada of Marquisate of Villavias. The senior Bodegas arrived in the late 1730s in Peru, where Tomas had been appointed to serve as *dusputado* (deputy) of the Consulado de Cuzco. They had five sons: Jose Antonio, Alberto, Manuel Antonio, Tomas Aniceto and Juan. Juan was their second son.

Unfortunately, Bodega y Quadra's life events between 1767 and 1774 are unknown to the pages of history. In 1762, at age eighteen, Juan Bodega y Quadra traveled to Cadiz, Spain, and entered the Spanish naval service. He

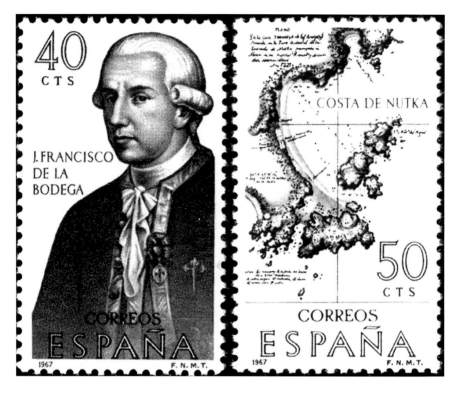

Portrait of Bodega y Quadra on a Spanish stamp series, released in 1967. *Courtesy of www. Momentoespanoles.es, accessed March 25, 2017.*

trained as a midshipman at the Department of Cadiz, which he completed in 1765. The young man received his commission in the Spanish Royal Navy on October 12, 1767. When the Naval Department of San Blas in Mexico was formed on the Pacific coast in 1774, Ensign Bodega y Quadra was one of six officers assigned from Spain. The base commander was Captain Bruno de Hezeta (commonly spelled "Heceta").

THE MAKINGS OF A CAPTAIN

During the course of a lifetime, a sequence of events can create an opportunity that can neither be planned for nor created deliberately; that person happens to be "at the right place at the right time." Some who are fortunate to experience this phenomenon seize this opportunity and use it

for all its potential. Such an event happened to Ensign Bodega y Quadra. It was the major turning point in his life.

The beginning of this turning point occurred in early 1775, when the viceroy of Mexico, Antonio Bucareli, ordered a second maritime exploration of the northwest coast of North America. On March 16, 1775, three ships set sail under the command of Captain Hezeta to explore as far north as 60° latitude (what is now Alaska). Captain Hezeta sailed the frigate *Santiago*, Don Miguel Manrique in packet boat *San Carlos* and Ensign Juan de Ayala in schooner *Sonora*, which Ensign Bodega y Quadra was aboard. The only reason Bodega y Quadra sailed aboard the *Sonora* was because he requested *any* assignment; it made no difference to him that, though equal in rank to Ayala, he would be junior officer to him. He was volunteering for action.

The schooner, by all accounts, was scarcely the type of vessel for examining the treacherous northern waters. It had a thirty-six-foot keel, twelve-foot beam and eight-foot hold, with a deckhouse/cabin being added for crew protection. The *Sonora*'s company, besides Ayala, consisted of officers Ensign Bodega y Quadra and Pilot Francisco Mourelle, a bosun's mate, a

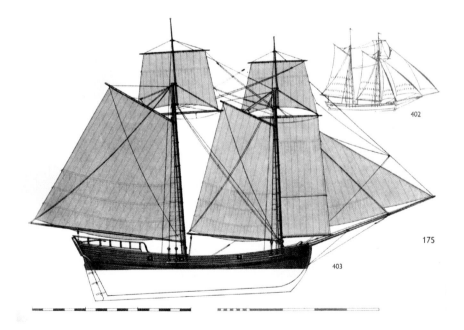

Sketch of a schooner similar to that of Bodega's *Sonora*. *Courtesy of* The Ship *by Bjorn Landstrom, 1961, p. 175.*

quartermaster, a steward, a page and ten seamen. Of the twelve sailors who served as able seamen, only four had ever been to sea.

Two days out of San Blas Naval Base in Mexico, problems arose on the *San Carlos.* A launch was sent out from Hezeta's *Santiago* and returned with Manrique, commander of the *San Carlos.* Hezeta wrote, "It was clear from his first statements he made he was incoherent." Friar Sierra, who was aboard the *Santiago,* described Manrique as a madman, his mind unhinged, who had increasing hallucinations. Manrique was returned to San Blas in a launch boat.

The turning point had been reached. This vacancy on the *San Carlos* caused changes in command, promoting Ensign Don Ayala as its new captain and subsequently charging Ensign Bodega y Quadra as captain of *Sonora.* Ayala and the *San Carlos* left the flotilla as the first ship to enter San Francisco Bay and into history.

The *Sonora* and *Santiago* continued the expedition, working their way north over the open Pacific. On June 9, at 41°4' north, they found a good anchorage off the shore of northernmost California that was protected from northwest winds (likely on the Mendocino coastline). Because of his uneasiness about the rocks and uneven bottom, Hezeta sent the smaller *Sonora* ahead to find safe anchorage. Commenting on the sailing of Bodega y Quadra, Hezeta wrote:

> *It was in this way that I secured complete success, because of the intelligence and devotion shown during the cruise by the schooner's commander, Don Juan Francisco de la Bodega y Quadra, and his pilot Don Francisco Mourelle. Not only have they been on the lookout for the most favorable sea for me to perform this dangerous maneuver, but they also contributed by carrying the greatest press of sail I have ever seen up to now, minimizing the very poor sailing qualities of the ship under his charge. Through his zealous vigilance he has avoided being swamped by the numerous heavy seas, currents and winds the two ships have frequently been subjected to, and which required of them, on such an extended voyage, the trouble of sailing in tow.*

Two days later, detachments from both ships went ashore, planted the Spanish flag and took formal possession of the land. After setting up a cross, the padre gave Mass and named the site "Trinidad." Some years later, Captain George Vancouver found the cross still standing in 1793 with the inscription, "Carulos III. Die G. Hyspaniorum Rex." This site still retains that name to this day.

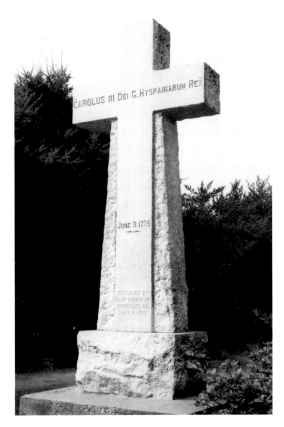

Left: Monument to Charles III, King of Spain, erected on June 9, 1775. The original wooden cross was replaced on September 8, 1912, by the Club Women of Humboldt County. *Photo by John C. Schubert, taken 1986.*

Below: Postcard photo of Trinidad Head along the Redwood Highway. The monument to Charles III is located at the top of the great mound across the bay from the photographer. *Courtesy of John C. Schubert Collection.*

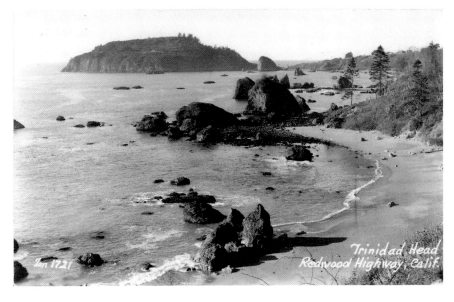

After ten days of replenishing the ships' reserves, the Hezeta-Bodega expedition left the California shores to continue north. Some three weeks after leaving Trinidad, the seas turned ugly; the ocean proved to be treacherous, as accounted by the following:

> On the 9th [of July] the northwest wind, which is the king of these seas, still continued, sending up heavy rollers and churning the sea into foam.... In the afternoon the wind became stronger and the sea more furious, and the Schooner found herself in difficulties, those on board being in danger of their lives. More sail have been raised on her than her construction warranted and owing to a sudden squall the main topmast gave way, which threw her on her beam ends and although the sails were struck she did not right and was in imminent danger of foundering; but the Divine Providence so willed it that a wave which broke on her masts righted her, and although some water entered the lazarette, damaging the stores, no great harm was done.

On July 13, after being tossed and thrashed by stormy seas for four days, the brace of ships made landfall again, this time at the Quinalt River on the Washington coastline. Upon Hezeta's orders, Bodega y Quadra sent six men from *Sonora* to get water and a new topmast. But misfortune struck. After the Spanish landed, Quinalt natives who lay in waiting on the forested shoreline attacked Bodega's crew and literally chopped the crewmen to pieces, reducing the *Sonora*'s crew by half. Their boat was also cut to pieces for the iron it contained. After the ambush, the natives were seen carrying parts of boat planking and the limbs of dismembered crewmen into the forest. The billets for the *Sonora* were, in turn, replenished with crewmen from the *Santiago*.

The ships left Quinalt country for open seas once again to explore the north coast, but the misfortune continued. Hezeta had a check made of his ships' crew and found twenty-nine sick from scurvy and related maladies, but he pressed on. The ships sailed together until bad weather separated them on July 31. When the storm ceased the following day, the *Santiago* was nowhere in sight; Bodega y Quadra pressed on through the choppy seas. The *Sonora* coursed on open seas until August 5, when they calculated their latitude was 46°30' (just south of the Columbia River). A southwest wind came up, allowing them to steer due north. They took advantage of it in their attempt to reach their goal of 65°.

Sonora sighted land ten days later at 57° (just south of Juneau) and came upon a safe harbor. They took possession of the harbor and named it "Los

Remedios" in the name of their Catholic majesty. Today, this is on the west coast of Kruzof Island in the Alaskan "panhandle." Here the mariners stocked up on fresh water and wood, and after a six-day layover, Bodega y Quadra resumed sailing.

At 58° (just southwest of Glacier Bay National Park), an excessively cold and rainy northwestern storm was encountered. The crew was sick and in rags; Bodega y Quadra decided to turn the rig south. On August 24, a large placid sound was discovered at 55°17' and was named "Bucareli Bay" in honor of the viceroy in Mexico. Located on the west side of Prince of Wales Island, it still retains this name today.

After six weeks of exploration off the Alaskan coast and fighting the elements, Bodega y Quadra decided to head for Monterrey, Alta California. He wrote:

> On the said days 29 and 30 of August, seven men were discovered with scurvy, some at the mouth and the others with various pains which impeded the movements of their legs, from which circumstances there remained only two men in each watch, one of whom was indispensable for handling the rudder.
>
> Finding myself with the men afflicted by their serious contagion, without having for their aid medicine, and the liability of having it spread to the others because there was not enough room to separate them, I knew that it would be impossible even though I exerted myself to sail farther north to a higher latitude. And even the return trip would be doubtful if the winds freshened vigorously, seeing we did not have enough men to handle the ship, and therefore I resolved to return, taking advantage of those winds that were favorable, and satisfying myself with reconnoitering the coast whenever I found it possible.

At 45°, winds blew the vessel farther out. The two officers took ill, but fortunately at the same time, two other seamen became well enough to stand watch and sail on. The ship arrived at the southern coast of Oregon at 42°50'. However, since the crew for the most part was still in bad health, they did not explore. As they traveled farther south, the weather turned fair and the crew greatly improved, as did Bodega y Quadra. The ensign-turned-captain returned to duty.

On September 6, as the *Sonora* continued south exploring, the schooner was hit by a large storm, with the seas breaking over the deck, resulting in the injury of the quartermaster. The remainder of the crew fought on but

nearly lost the ship by capsizing. By September 8, the tempest had slackened, leaving only four sailors well enough to handle the ship: Bodega y Quadra, the pilot Mourelle and two crewmen. With so few hands working, they stood out to sea until milder weather was encountered. Bodega y Quadra wrote in his narrations of this voyage:

> On the 22nd [of September] the Northeast winds came back, but due to the misfortune of both the Pilot and myself being ill at the same time with high fevers and suffering from the pains of scurvy, it was absolutely necessary to make way directly toward Monte-Rey.
>
> The few sailors who were still well and the sick ones became most greatly disturbed seeing that we were ill to the point that they imagined us all to be lost; but being apprised of their dejection, we made a great effort to present ourselves on deck, and God decided to help us in our effort.
>
> On the 24th, feeling somewhat better, I sighted land and this was discovered at 45 degrees 27 minutes; from this point I began exploring it so quickly that I only stood off from it for barely a mile and a half anchoring at night at whatever spots along the coast when the sun would set, so as not to lose the merest distances, expecting to look for the Martin de Aguilar river, which was not found, nor is it found between said latitude and 42 degrees 50 minutes. There we saw a cape slicing into the ocean which forms the shape of a table [Cape Blanco]; and drawing away from there is the coast to the southeast and several headlands to the South southeast.
>
> From the last sighting I went on with the same enthusiasm looking for the port of San Francisco, not leaving a single cove out and on the 3rd [of October], finding ourselves at latitude 38 degrees and 18 minutes, I went in through a bay…which I covered in my run until I got to the Southeast side where I discovered the mouth and an enormous river and going in, I saw that it formed a grown port as it shows on the chart; at the same time the sea grew extraordinarily violent and naturally, I thought it might be the port I was looking for; this is the reason I went in and anchored across from Point Arenas right along the coast at Point Cordon in 7 fathoms of water, waiting around to hear from those people who it seemed to me must have settled there, but when all day long we did not see even signals from them, I doubted then that it was the port of San Francisco.
>
> The Indians that were there were innumerable and they passed by us in tule canoes from one shore to the other, to come over to a nearby hill where we had anchored and when many had gathered they began to call out for more than two hours without stopping at the end of that time, two came

alongside us and with the greatest of openness they gave us feathers, bone necklaces, a basket of seeds which tasted like hazelnuts and various trinkets of this sort; I repaid their offerings with kerchiefs, mirrors and beads and they went off quite happy.

The stature of these people is robust and corpulent, but their coloring is olive toned. There is no difference at all between them and the other Indians that I have seen except for their hair-do which they wear much in the fashion that the ladies of Spain are again using.

The port is situated at a latitude of 30 degrees, 18 minutes and 32 and 9 minutes longitude at the Occidental of San Blas; it swells indeterminately towards the Southeast and is such a perfect shelter that the entire thing is an inner harbor. And I did not inspect the interior depth because I wanted to set the sick on land pitying them as I could see them approaching the end, almost, without having had the least relief. For this reason I tried to put myself in a maneuverable position so that the Nor'easter would not block my exit and I immediately returned to anchor at the point which I had named el Cordon.

On the 4th at 2 in the morning the other tide began to swell and at 4 in the morning the waves broke against the ebb tide so violently that some of those swells breaking over the ship covered us from bow to stern and one of them tore off the lorry smashing it into a thousand pieces and at the same time one of the anchors failed making it impossible for me to hand it up against as I found myself without a lorry.

Since the entrance is not wide enough to let out that sea it causes currents at the place to go in and out with tremendous force and the tides to break at the opening whenever the bad weather causes their turbulence.

If I were apprised of this happening (which is not always the case), I would have stayed at the first stop or would have gone further out where I would not experience any such seas.

The depth over all of what I have seen is average as shown in the Chart numbered in fathoms.

Then entry to said port is easy since the Nor'easters are at the stern going in; but the exit, if it isn't done with a Southeaster forces one to wait for the flood tide and then with its pull raise sail which is not difficult giving the forces of the waters.

The tides as I observed that day of the conjunction carry high water at 12 and their timing is 6 hours and 1/5 in each rising or flooding.

The seas are empty and so is the immediate area; it is only in the very interior that one sees many woods but on the flatland of the beaches they are green and pleasant, perfect for magnificent cultivation.

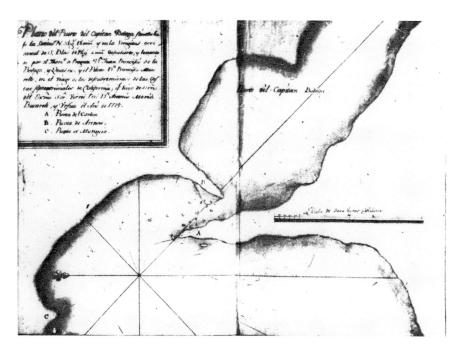

Bodega's harbor chart of 1775. *Courtesy of AGI, Estado 38, Mexico 19. Microfilm, BL.*

At 8 the breaking of the waves had ceased and two canoes came up to us together with another one, which they have given us without requesting any recompense. This is such open generosity which I have not experienced from the rest. I satisfied them with the best I could find and they went off with demonstrations of great joy.

Don Francisco Mourelle, Bodega y Quadra's pilot, wrote in his journal:

Whilst we were in this port (which we did not conceive to be that of S. Francisco) we had no further intercourse with the inhabitants, and we prepared to clear the point de las Avenas, in order that, with a Northwest wind, the next day we might, with less difficulty, leave this part of the coast. Having effected this, we cast anchor in six fathoms, the bottom being a clay. This port, which we named de la Bodega, is situated in 38.18 North Latitude and 18.4 West Longitude from San Blas....

... The mountains near this port are entirely naked in every part of them; but we observed that those more inland were covered with trees. The plains near the seacoast had a good verdure, and seemed to invite cultivation.

22

> *About eight in the morning of the 4ᵗʰ of October the sea became more calm, on which the Indians came round us as before, offering us the same presents, which had the same return.*
>
> *At nine we set sail, and having doubled the point del Cordon we steered South-Southwest and the wind being moderate, and at West in order to reach a Cape, which appeared to the South at the distance of about five leagues* [Point Reyes].

Who exactly named the bay he entered after Ensign Bodega y Quadra is not known. Mourelle does not state; only the term "we named" is used. But regardless, Bodega Bay, Bodega Harbor and Tomales Bay would be known today by different tributes had it not been for the fact that his crewmen fell ill and he set out to sail closer to the shoreline.

Sonora continued south, arriving at Monterrey on October 7. There, riding at anchor, was the *Santiago*. Hezeta and his crew were glad to see the other half of the expedition, and since they had not seen *Sonora* for over two months, they figured to give them up for lost. Nearly all crew members were sick with scurvy but recovered under the care of the padres of Monterrey. The return trip from Monterrey to San Blas took from November 1 to 20. The entire expedition, from the time they left San Blas to their return, lasted eight months.

From Ensign to Commandante

Juan Francisco de la Bodega y Quadra was outstanding and meticulous in charting harbors and making entries in his journal. His notes were profuse and have since been proven accurate. He also made many entries describing biology and ethnology.

Upon Bodega y Quadra's return to San Blas, praise was heaped on him and his promotion was made to full lieutenant. The viceroy of Mexico, Bucareli, recommended the new lieutenant for Knight of the Order of Santiago. To qualify for this order, the nominee had to have shown exceptional valor on a military assignment and have "unimpeachable lineage."

Following an inquiry in 1904 about Bodega y Quadra, the secretary of the Royal Academy of History in Madrid wrote:

> *Twenty four witnesses convoked in Madrid, in San Julian de Musques, in Bilbao and in San Salvador del Castro de Oro (Calicia), for proving*

Cross of the Knight of the Order of Santiago; this cross would have adorned these medals of honor. *Courtesy of Heralder— Own work, CC BY-SA 3.0, commons. wikimedia.org/w/index. php?curid=16688150, accessed March 25, 2017.*

the nobility of the family; declared in the writs that they had an ancestral house and coat of arms in San Julian, and that the ancestors had been mayors, magistrates and captains, on account of all of which, and in view of the documents proving it, the insignia was conceded to Don Juan Francisco in 1776, at that time lieutenant in the Royal Navy, stationed in California.

Bodega y Quadra passed the inquest and was knighted.

Viceroy Bucareli was of a mind to send another exploring party up the West Coast of North America. Two new vessels were needed, plus crews and supplies. The viceroy, through Hezeta, ordered the new knight to go to Callao, Peru, to purchase a frigate, as San Blas was in constant shortage of iron, especially during the war with England. Lieutenant Bodega y Quadra was pleased; he had not seen his family for many years and wished to personally show them his two new accolades. The lieutenant was gone from San Blas for fifteen months, returning on February 27, 1778. During that time, he obtained the frigate *Favorita*, of 193 tons burden, purchased supplies and hired crewmen. Meanwhile, another frigate, the *Princesa*, was being built at San Blas.

From April to December 1778, Bodega y Quadra and Commander Arteaga of the San Blas Naval Department prepared the ships for a hard and long cruise, laying in special provisions to last a year and clothing better suited for the northern country. During November, the viceroy appointed the remaining officers to billets on the ships. On Bodega's *Favorita* were Francisco Mourelle, second officer who had sailed with Bodega y Quadra in 1775 to Alaska; Jose Canizares and Juan Bautiste as pilots; Cristoval Dias as chaplain; and Mariano Esquivel as surgeon. The *Princesa* was filled with a like complement.

The last orders for the expeditions were to sail directly to the northwest coast without stopping at any California port, chart and explore that coast and achieve 70° N latitude (the edge of the Arctic Ocean, yet unknown to them). The expedition left on February 11, 1779, and arrived at the desired coast of Bucareli Bay at 55° on May 3. They stayed six weeks investigating and charting Bucareli Bay and neighboring shores to the north. The two

companies weighted anchor on July 1 and, eighteen days later, arrived at the northernmost point of 60°30' North (today known as Prince of Wales Sound) on the south coast of Alaska. They rode at anchor three days and then sailed southwest toward Kenai Peninsula on July 24. On August 2, they cast anchor on the west shore of Cook's Inlet, approximately seventy-five miles from today's Anchorage.

In the meantime, scurvy was rampant on the ships and the climate was taking crew members out of service. Arteaga was severely sick; eight men died, and many others were in critical condition. However, despite illness, Bodega y Quadra, with Mourelle, Canizares and other pilots, continued exploring. Arteaga's second officer begged they move south, but Bodega y Quadra wanted to carry on with the task assigned by the viceroy to search for new lands and trace the Alaskan Peninsula. On August 7, Arteaga, the expedition's leader, faced with continued outbreaks of scurvy and still racked with his own sickness, gave the order to weigh anchor and sail directly to the ports of California. The vessels were separated. Bodega's *Favorita* made landfall at Trinidad, California, on September 4 and ten days later dropped anchor in San Francisco Bay. The following day, *Princesa* arrived.

San Francisco was a paradise. Lush native lands and the padres of Missions Dolores and Carmelo nursed the remainder of the crews back to health. Being put ashore, the men were fed fresh vegetables and meat. Bodega y Quadra and Mourelle gave special attention to their crew. Both officers ministered to their sick personally, even though most of their time was used to complete their journals and surveys of this last voyage. Their stay was cut short at San Francisco when a courier brought news of Viceroy Bucareli's death and the declaration of war against England. The two ships left on October 30 and arrived at San Blas on November 21, 1779. No further explorations were made until hostilities ceased with England.

In May 1780, Juan Bodega y Quadra, promoted to full commander, was ordered to Havana to prepare for action with the English, but by the time he arrived in Cuba, the international conflict was over, and he set sail to return to San Blas. On June 5, 1781, the newly appointed commander sailed the *Santiago* for Callao, Peru, where he loaded with cannon, artillery and iron. He returned to San Blas a year later.

In 1783, at thirty-nine years old, the commander was transferred to Spain. Sailing by way of Havana, he arrived in Spain and reported for duty at the Department of Cadiz, where he had served as midshipman twenty years before (an enviable assignment in those days). For the next six years, Bodega y Quadra, now captain, served primarily as a naval advisor, but he also

instructed midshipmen at Cadiz and Cartagena because of his exploration experience in the Pacific Northwest. During those years in Spain, he also took the opportunity to visit the Basque towns in the ancestral homeland of his parents.

While at government conferences in Aranjuez, Captain Bodega y Quadra testified concerning Spanish defenses, exploration and the development of the Pacific coast of the Americas, as he had firsthand knowledge of all the ports north of San Blas. Most of his statements were negative. He felt that if called upon, most of the Spanish presidios or fortified locations could fire only a few salvos and hope the shots would turn away the hostile forces. Alta California was too vulnerable from the north and the sea. One of Bodega's comments reiterated by the Viceroy was, "There is a woeful lack of ships at San Blas. Without ships, the coast can not be patrolled nor defended." Some of the problems were resolved via court meetings and advice of ranking naval officers.

In the spring of 1789, Captain Bodega y Quadra was made commandante of the Naval Department of San Blas. He was forty-five years old. On May 26, Bodega, with others, left Cadiz aboard the *San Ramon* and arrived approximately three months later, during mid-August, at Vera Cruz, Mexico.

During these years, 1779–89, Commandante Bruno de Hezeta wished to be transferred from San Blas. His first request was in 1779, the second in 1782. Each succeeding year had a request from Hezeta until 1789, when the transfer was finally granted. Temporary command of San Blas Naval Department was given to Ensign Jose Martinez, who served as a pilot at San Blas in 1778, pending the arrival of Bodega y Quadra.

Because of Bodega y Quadra's and Hezeta's explorations of 1775 and 1779, Spain laid claim to the western coasts of Alaska and Canada, even though no structures had been erected or settlements established. However, because of these northern explorations, one location became a more dominant port: Nootka. Nootka Sound (located on the west side of Vancouver Island, Canada) was a haven and main anchorage for the Spanish, as well as the occasional English vessel (which were becoming more frequent). Inside this sound was Friendly Cove, the favorite anchorage.

A year prior to his command of San Blas (1788), Ensign Martinez was given charge of an expedition after alarming information was passed to the Spanish authorities: Russian settlements, permanent ones, were appearing along the Alaskan coast. The information was confirmed by Martinez going north and finding that approximately 460 Russians were stationed along the coast. The Spaniards returned to San Blas with the news and updated charts

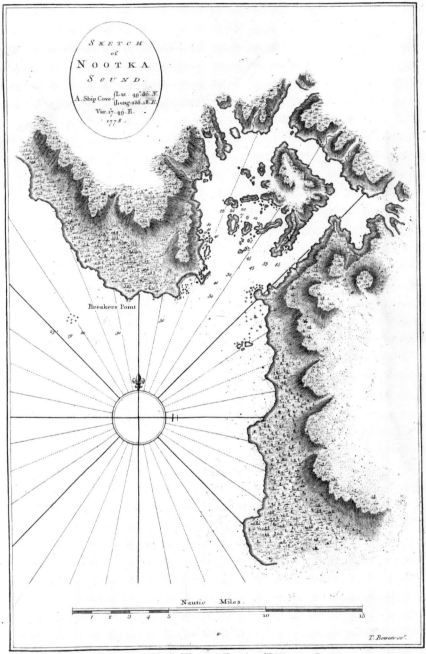

Nautical sketch of Nootka Sound, Alaska. Published by Alex Hogg of Kings Arms, London, 1778. *Courtesy of John C. Schubert Collection.*

in December 1788. Other information was received in Mexico that two American ships were on the Alaskan and Canadian coast. Upon hearing this news, the viceroy immediately ordered another expedition with the same officers. Haste was not fast enough for Viceroy Revilla Gigedo to get Spanish authority back to the northlands. After two months' stay to refurbish and replenish the ships at San Blas, the now more-military-than-exploratory force left in February 1789, with Martinez at the command.

The "Spanish Guard" arrived at Nootka by the end of April and dropped anchor. Information came: there were four English ships in the area. Their neighbors, besides Nootka natives, were two Boston trading ships. The Americans were well hosted, as the Spanish in this remote corner of the world needed all the friends they could muster. The Spanish built a substantial settlement at Friendly Cove consisting of a fortress equipped with cannon fire, a lodge house, a workshop, gardens and more. They were emphatic about enforcing their territorial claims as more Americans would appear on the Pacific, for they had just won their revolution against England.

As soon as the Spaniards learned of the English plans to also garrison Nootka, Martinez took three British ships and their crews prisoner. These vessels were sailed to San Blas under the Spanish flag with Spanish officers and crew, all while the British remained on board as prisoners. A packet boat arrived in July from San Blas with instructions for all Spaniards to return. Martinez reloaded his ships and left at the end of October, "abandoning" Nootka. The flotilla arrived home on December 6, 1789.

While these events were occurring, Captain Bodega y Quadra arrived back at his old naval station on September 18 and assumed command. As soon as he familiarized himself with the Northwest situation and received Martinez, he ordered another naval expeditionary force to assemble under the command of Francisco Eliza. Bodega wrote to Viceroy Gigedo: "I labored in all matters of preparation, including the effort of collecting artillery and fresh provisions and thus it has been possible to launch the relief expedition for Nootka in a period of thirty-six days." Three ships were ready and set sail on February 3, 1790, to reoccupy and supply Nootka.

Captain Bodega y Quadra had issued to Commander Eliza a nineteen-article order: "Secret Instructions to Francisco Eliza." The articles could be divided into three groups:

1. Treatment of the soldiers and sailors. The commander must be careful in judging and issuing corporal punishment; many of the men served on naval vessels;

2. Instructed the mounting of the twenty cannons in the best location at Friendly Cove;
3. Ordered further exploration north and south of Nootka.

The ships arrived on station mid-March.

One officer, Ensign Manuel Quimper, commanding the *Princesa Real*, left Nootka at the end of May to explore deep into the Straits of Juan de Fuca. About July 5, Quimper sent his pilots in small boats along the southern shores of the strait. They proceeded, giving names to points of land and bays. Near the eastern side of the strait "they came to an admirable harbor which they called Puerto de Bodega y Quadra with an island in front of it." This port (now called Port Discovery) is located on Washington's Olympic Peninsula.

Meanwhile, the political problem relocated at San Blas, made worse by the overreaction of Martinez, was slowly corrected by the viceroy of Mexico and Bodega y Quadra. The English prisoners in Mexico were under a loose "house arrest" for the one year they spent at the Mexican port. In an attempt to neutralize their frustrations, Viceroy Gigedo wrote the Englishmen a promise to settle all their losses. During the negotiations for the release of the ships, their crews and themselves, Captains Colnett and Hudson came in contact with Captain Bodega y Quadra on many occasions. The day before Captain Colnett was finally released and left San Blas, he wrote:

> *Commander Juan Francisco de la Bodega Quadra,*
> *I will always gratefully acknowledge the good journey and the civility with which I have been treated in this country where I have been a prisoner in name only, for with the prerogatives which the kindness of Your Lordship has granted me, my officers and I have had the regard of the Commissary and of the whole Department; in a word I am leaving entirely satisfied with the benignity and favour of His Excellency the Viceroy, with the attentions of Your Lordship and of the whole Kingdom, but I must ask you, and do not be surprised, to permit me upon my arrival, after manifesting my gratitude, to clear myself of all responsibility for the damages and delays which the Company has suffered because of Martinez and the bad faith with which he seized me, which action I shall never be able to forget.*
> *May God keep Your Lordship many years.*
> *San Blas, July 8, 1790*
> *We are Grateful.*

THE EXPEDITION OF LIMITS

In the meantime, things were happening half the world away in Europe that would propel Captain Bodega y Quadra and another well-known seaman, Captain George Vancouver of his Britannic Majesty's navy, to meet on distant shores. The news of Martinez confiscating Englishmen, English ships and "English territory" reached Parliament in London. England threatened Spain with force on the largest scale. The English flag had been violated. Because of various treaties and pacts between countries, nearly all of Europe would be involved in war. Through their respective ambassadors, England and Spain negotiated a settlement as to land, trading and hunting rights. On October 28, 1790, the officers of the courts signed the Nootka Convention. The land boundary would be a line chosen by appointed agents of the adversary courts. The commissioners to rendezvous at Nootka were Captains Bodega y Quadra and Vancouver. This assemblage was called "Expedition of Limits."

On his voyage of world exploration, Captain Vancouver of the brig *Discovery* received instructions dated August 20, 1791, that he would act for England. He arrived at Nootka and Friendly Cove on August 28, 1792, a year later. The Spanish delegation left San Blas on March 3, 1792, arriving in April at Nootka. Captain Vancouver wrote in his journal:

> *As Señor Quadra resided on shore, I sent Mr. Puget to acquaint him with our arrival, and to say, that I would salute the Spanish flag, if he would return an equal number of guns. On receiving a very polite answer in the affirmative, we saluted with thirteen guns, which were returned, and on my going on shore accompanied by some of the officers, we had the honor of being received with the greatest cordiality and attention from the commandant, who informed me he would return our visit the next morning.*
>
> *Agreeably to his engagement, Señor Quadra with several of his officers came on board the* Discovery, *where they breakfasted, and were saluted with thirteen guns on their arrival and departure; the day was afterwards spent in ceremonious offices of civility, with much harmony and festivity. As many officers as could be spared from the vessels with myself dined with Señor Quadra, and were gratified with a repast we had lately been little accustomed to, or had the most distant idea of meeting with at this place. A dinner of five courses, consisting of a superfluity of the best provisions, was served with great elegance; a royal salute was fired on drinking health to the sovereigns of England and Spain, and a salute of*

Portrait of Captain George Vancouver, accessed March 25, 2017. *Courtesy of National Portrait Gallery, London. commons.wikimedia.org/wiki/File:Probably_George_Vancouver_from_NPG.jpg.*

seventeen guns to the success of the service in which the Discovery *and* Chatham *were engaged.*

Marquinna (leader of the area's native population), who was present on this occasion, had early in the morning, from being unknown to us, been prevented coming on board the Discovery *by the sentinels and the officer on deck, as there was not in his appearance the smallest indication of his superior rank. Of this indignity he had complained in a most angry manner to Señor Quadra, who very obligingly found means to soothe him; and after receiving some presents of blue cloth, copper, etc., at breakfast time he appeared satisfied of our friendly intentions: but no sooner had he drunk a few glasses of wine, than he renewed the subject, regretted the Spaniards were about to quit the place, and asserted that he should presently give it up to some other nation; by which means himself and his people would be constantly disturbed and harassed by new masters. Señor Quadra took much pains to explain that it was our ignorance of his person which had occasioned the mistake, and that himself and subjects would be as kindly treated by the English as they had been by the Spaniards. He seemed at length convinced by Señor Quadra's arguments, and became reconciled by his assurances that his fears were groundless.*

With formal introductions completed and the socio/political environment established, the major point of business was approached. The problem to be settled from Spain's view was that it had nothing to deliver:

1. The ships had been returned;
2. No damages to fix (compensation paid); which left only
3. Establishment of Territorial Boundaries.

Bodega y Quadra wished to remove all obstacles and create a solid peace pact before ceding to England structures, outbuildings, gardens, etc. But this would be done without Spain relinquishing its legitimate rights to Nootka. Vancouver wrote, "I did not consider myself authorized to enter into a retrospective discussion on the respective rights and pretensions of the Courts of Spain or England…That subject having been agreed upon by the ministers of the respective courts."

However, Vancouver accepted the offer of Bodega y Quadra in that he would, for the present, consider Nootka as a Spanish port and would carry on with his work ashore. The Expedition of Limits lasted almost a month. The one positive result of this meeting was the close friendship and respect

the captains had for each other. A demonstration of this mutual admiration is examined in Vancouver's journal:

> *Señor Quadra had very earnestly requested that I would name some port or island after us both, to commemorate our meeting and the very friendly intercourse that had taken place and subsisted between us. Conceiving no spot so proper for this denomination as the place where we had first met, which was nearly in the center of a tract of land that had first been circumnavigated by us, forming the southwestern sides of the gulf of Georgia, and the southern sides of Johnstone's straits and Queen Charlott's sound, I name the country the Island of Quadra and Vancouver; with which compliment he seemed highly pleased.*

This was done on September 5.

THE CAPTAINS' DEPARTURE

When the Spaniards left on September 22 for California, the Spanish captain gave Nootka *en toto* to Vancouver's command for his use. Bodega y Quadra lowered the Spanish flag, signaling his leave of Friendly Cove; however, he would not be the Spanish officer to lower colors, signifying Spain's leave of the Northwest. Bodega y Quadra's voyage south lasted seventeen days, arriving in Monterrey, California, on October 9. Vancouver left Nootka on October 12, exploring his way south. Vancouver had license to wander all of Alta California, should he so desire, to survey presidios and scrutinize the missions and pueblos (under the guise of "scientific pursuit," as his cruise was declared). He arrived in Monterrey on November 27. Bodega y Quadra supplied the English ships with any of their wants, accepting no payment and giving strict orders that no account whatever should be rendered, much to the irritation of the governor of California, Arillaga, who had received direct orders from Viceroy Gigedo, dated November 24, 1792, for him to be on his guard for English vessels. Regardless, the two captains continued their established friendship. Again reverting to Vancouver's own words describing Bodega y Quadra: "To the reverence, esteem and regard that was shown Señor Quadra by all persons and on all occasions, I must attribute some portion of the respect and friendship we received."

December passed to the New Year of 1793. After an enjoyable delay of seven weeks, the day of departure drew near. On the evening of January 6,

Vancouver gave a farewell dinner for Bodega y Quadra and the Spanish port officers. On the fourteenth, Vancouver weighed anchor on *Discovery*, followed the next day by *Chatham*, *Aransasu* and *Activa* with Bodega y Quadra. The four vessels sailed at leisure southward until the fourth day out. It was time to bid farewell. A parting dinner was given on *Discovery*. It marked the close of the association but not the friendship of the two officers and gentlemen. Vancouver wrote, "The wind blew a gentle breeze from the north; the serenity of the sky and smoothness of the sea prolonged my pleasure on this occasion until near midnight. Amongst all that valuable society…the prospect of never again meeting Senor Quadra and our other friends about him was a painful consideration."

The Spanish headed for San Blas, the English for Hawaii.

The Spanish captain's next major assignment was to lay and execute plans for the occupation of Bodega Bay in Alta California. An expedition was organized at San Blas in March 1793, but command was given to a junior officer because the captain became ill.

By June, Bodega y Quadra's health had deteriorated so badly that he requested sick leave. With his personal chaplain, he went to Guadalajara and seclusion. While there, he suffered a seizure and was moved to Mexico City. He died on March 26, 1794. Captain Juan Francisco Bodega y Quadra, native of Lima, Peru, was fifty years old. He now lies in San Blas.

Captain Vancouver returned to Nootka on September 2, 1794, and found three Spanish ships riding at anchor. From the senior officer, he learned of Bodega y Quadra's death. Vancouver penned:

> *I cannot refrain, now that he is no more, from rendering that justice to his memory to which it is so amply entitled, by stating that the unexpected melancholy event of his decease operated on the minds of us all, in a way more easily to be imagined than described; and whilst it excited our most grateful acknowledgments, it produced the deepest regret for the loss of a character so amiable, and so truly ornamental to civil society.*
>
> *He was my intimate friend whose death grieves to the soul.*

Chapter 2

A CLASH OF CULTURES

First Encounters and Native Wars

TRIBES, LEADERS AND VILLAGES

The Pomo and Wappo peoples of Sonoma County occupied territories in neighboring Mendocino, Lake and Napa Counties for many thousands of years. The Miwok habituated southern Sonoma and all of Marin Counties. The Pomo were composed of several language groups, which were determined by their geographical location. Those in Sonoma County were the Kashaya-Pomo, located along the coastline, with the Southern Pomo living in the central valleys of the county. In the early 1800s, Spanish records combined several but not all villages of the Southern Pomo under the name Kainomero [ki-no-mare-oh]. The Spaniards named one leader or "chief" *Gallina*, from whom the name Gallinomero or Kainomero derived.

Some Kainomero villages and leaders were the Shawako with Chief Tupu, located in the Dry Creek Valley, and, near Healdsburg, the Amitio under Chief Yihutciu [yee-hoo-chi-oo], the Mikakotcali led by Tculanuk [chool-ah-nook] and the Kale [ka-lay] with Ventura. Ventura was one of the last "chiefs" and had twenty to thirty people under his guidance until about 1870. To the north was the village of Kaiaictenin [ka-ee-ah-ee-chen-in], a Kainomero group in the area of Lytton.

East of Healdsburg was the Wotok-Katon, whose best-known leader was Soto. From him came the name of the people in the area: Sotoyome [so-tow-yo-may]. Another chief mentioned with the Sotoyome was Moti.

To the south in the Santa Rosa area were the Bitakomtara [bee-ta-comb-tah-ra]. Their main permanent village was Katetcinwa [ka-te-chin-wa]. Its last leader was Tco-con [cho-koan]. The Konhomtara lived near Sebastopol on the west side of the Laguna de Santa Rosa. Their chief, Mateyo, was said to have been the leader of all the Kainomero. The most important village was Levantolome, located about five to six miles north of Sebastopol.

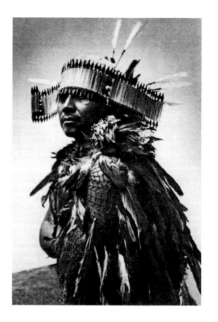

Pomo man dressed in dance regalia, with red headband and feather adornments. *From John C. Schubert's* Guerneville Early Days, *courtesy of Hearst Museum at University of California–Berkeley.*

Another tribe of Sonoma County was the Wappo. The name is derived from the Spanish, who called them *guapo* or "brave." They controlled the eastern quarter of the county, being all of Sonoma Valley up through that part of Alexander Valley lying east of the Russian River. Their principal village, Pipoholma, was rather large with forty dwellings and a sweat house, located opposite that of Geyserville. Their leader was Michehel.

Another Wappo town was Unutsawaholma [oon-oot-sa-wa-holm-ah], also known as Koloko, just south of Pipoholma. One leader was Holimikali. One other village was Willikos, known today as Los Guilicos (Spanish spelling style), east of Santa Rosa.

Southern Sonoma County was the territory of the Coast Miwok. Their two principal towns in Sonoma County were Petaluma and Olamentko near Bodega Bay. The populations of the Southern Pomo and Coast Miwok are unknown during these historical times leading up to 1850. There are estimated to have been four thousand Wappo in 1770.

WEAPONS AND PREPARATION

The weapons used by the Pomo, Miwok and Wappo were, for all intents and purposes, the same for warfare as for hunting. Bows and arrows were

common. The bow was sinew-backed, about three feet long and well decorated. Arrows sometimes had poison applied to them made of snake's blood or that of a large lizard. The quiver was held in the left hand and used as a shield.

War slings were made with a pouch of hide. Their two strings were from two to three feet long, one end in a loop for the finger, the other end in a knot. Sling throwers remained a little way to the rear of the battle line and were supplied with small stones brought to them in baskets by boys. A good slinger could hit a fence post at seventy-five yards.

Spears were made and used occasionally in war. The shafts were about equal to the height of a man or a little more and about an inch in diameter. The spearhead was about six inches in length and made of obsidian or chert. They were used for thrusting but were thrown on rare occasions when required. The Wappo used the spear chiefly for surprise night attacks.

A war club was made of yew or manzanita branches and was about two feet long. The business end was knob shaped and was wielded by the hands of the warriors.

The Pomo made a type of double-rod armor that must have been quite effective as a protection against arrows. It completely covered the wearer's trunk, protecting all the vital organs. It was made from the rods of the snowberry bush and was about the diameter of a pencil and consisted of two layers, the outer layer vertical and the inner layer horizontal. They were held together by tightly woven cordage. The whole device was rigid but compensated by its protection.

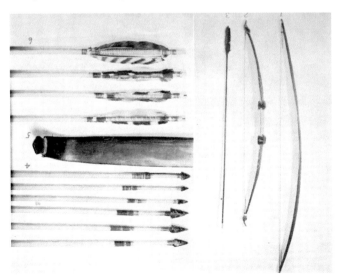

Pomo Indian bows and arrows. *Courtesy of* Material Aspects of Pomo Culture, *part 1, by S.A. Barrett, Public Museum of the City of Milwaukee, March 1952, p. 242.*

Prior to going into battle, warriors painted themselves with charcoal and red clay around the mouth, on the cheeks and on the body. Pre-battle rituals were extremely important and consisted of prayers and the men singing a war song that usually mentioned the pigments and/or saying the foes would be weak: "Their arms shall be down and their eyesight dull."

NATIVE VS. NATIVE

While most native cultures in the region were considered peaceful, battles were not out of the norm, especially when concerning the trespassing of territory. The Pomo and Wappo did not fight wars for honor, prestige or reward but rather for avenging a wrong act perpetrated on them, either on their persons or their property. Inter-settlement wars were known but rare in Sonoma County. Large skirmishes did take place, but even these were likely to cease if a prominent man was killed, especially the one who was responsible for the conflict. Trespassing without permission or payment was enough reason to give rise to an altercation. An example of this was given:

A central Pomo, name Tsulu, speaking in 1902, stated that a very old man, about 25 years previously, had described to him a battle which he, when a boy, had seen (circa 1820). The occasion was a fight between some Kula'Napo of Big Valley (Mendocino County) and some men who came from the vicinity of Healdsburg (Southern Pomo). The latter were surrounded in a patch (4 or 5 acres) of very thick brush and held them there for 4 or 5 days and nights. Early in the fight it began to rain heavily and some snow fell. The bows got wet and the bow strings slackened. Hence no effective fighting could be done by either side. Finally, those who were trapped effected their escape by simulating bears. They bedecked themselves with leaves and branches and otherwise made themselves as frightful looking as possible. All rushed out of the thicket together and frightened their adversaries and thus made their escape before a counter attack could be organized. They left their suits of armor in the thicket, apparently to facilitate their movements in the dash to escape.

The only fatalities in the fight were in the ranks of the Kula'Napo. Two or three men who attempted to flee by jumping into a swollen stream were drowned.

There were definite tensions between the Bitakomtara of Santa Rosa and the Konhomtara of Sebastopol, who resided in proximity to each other. Being on the opposite sides of Laguna de Santa Rosa, war would result if a trespass was discovered.

Another example of territory tensions happened around the year 1830, when the Western Wappo and Southern Pomo came together in conflict. Both tribes were located in Alexander Valley, north of Healdsburg, with their respective territories divided by a small creek they called Popoech, which flowed west to the Russian River. The Wappo were from Pipoholma on the east side of the river, and to the south of them were the Pomo of Ossokowi and Chehelle. One afternoon, the Wappo were gathering acorns on their side of the dividing creek but left them piled and went home to Pipoholma. During the night, the Pomo of Ossokowi made off with the piles. Their being so close threw suspicion on them, and the Wappo had no trouble in tracing the tracks. Their leader, Michehel, with about ten of his Wappo, stole into Ossokowi at night and killed two of the Pomo. The following morning during the cremations of the victims by the relatives and during the confusion of the funeral wailing, Michehel attacked again, but this time in full force. They killed many Ossokowi Pomo, scattered the rest and burned the town to the ground.

While the victorious Wappo were cremating the fallen, the surviving Pomo, having taken refuge downstream near Healdsburg, sent word that they wished to end the feud. A meeting was arranged on the plains east of Lytton between Michehel and his Pomo counterpart. As they exchanged gifts, Michehel told the Pomo they were free to return in peace to the five neighboring villages and the vacant Ossokowi. However, the Pomo did not feel at ease so near their recent foes and told the Wappo they would locate elsewhere. Michehel's people were at liberty to occupy the settlements. Part of the Wappo subsequently resettled in Ossokowi and Chehelle. The remaining villages were abandoned. It is believed that the Wotok-Katon Pomo, whose territory was east of Healdsburg, were involved in this conflict as mediators between the warring factions and as sanctuary for the refugees.

The Shawako people, Pomo of Dry Creek, at one time or another were in conflict with the Wappo.

Other encounters existed in all regions of the territory whose motives were more disturbing in nature. On the coast of Sonoma County is the Russian establishment Fort Ross. The manager of the settlement from June 1829 to 1836 was Peter S. Kostromitonov. Recorded among his notes on the natives was a disturbance in the inland valleys of the county:

A few years ago the Makamov Indians and those Kajatshin came to blows in the plains of Slavianka (Russian River). The cause was that the Makamov Indians have invited a Tojon (an acknowledged leader) for a visit and had suffocated their guest in his bath. The argument lasted a year, and on various occasions about 200 men from both parties were killed until finally, weary of fighting, they settled the matter amicably and exchanged gifts.

Taking into consideration Kostromitonov's foreign spelling, the "Makamov" could be a reference to the Makoma (residing near the mouth of Sulphur Creek, located near today's Cloverdale), and the "Kajatshin" would be the Gaiyachin of Alexander Valley, at this time belonging to the Wappo near Lytton. In surveying various accounts of Pomo battles, the number of two hundred fatalities appears to be rather high. One could deduce there is a strong possibility that the allies of the respective villages must have also been involved.

COMING OF THE WHITE MAN

The battles fought among these native tribes, while brutal in nature, would not prepare them for the onslaught that awaited them. It is common knowledge that cultural shock occurred wherever European culture met Native American culture. And while some contacts were violent, some were not, and the natives were gradually assimilated into the expanding domain of the invading Europeans. The first contact between Sonoma County natives and Europeans was not physical or violent. The specific date of the following incident is unknown, as it was recorded in the traditional oral history of the Kashaya people (Southwest Pomo) living on the Sonoma Coast:

In the old days before the white people came up here, there was a boat sailing on the ocean from the south. Because before that they had never seen a boat they said, "Our world must be coming to an end. Couldn't we do something? This big bird floating on the ocean is from somewhere, probably from up high. Let us plan a feast. Let us have a dance." They followed its course with their eyes to see what it would do. Having done so, they promised Our Father [a feast] saying that destruction was upon them.

When they had done so, they watched. The ship sailed away up north and disappeared. They thought that the ship had not done anything but

sailed northwards because of the feast they had promised. They were saying that nothing had happened to them—the big bird person had sailed northward without doing anything—because of the promise of a feast; because of that they thought it had not done anything. Consequently, they held a feast and a big dance.

A long time afterwards, when white men had come up and they saw their boats, they then found out that what they had thought was a big bird was otherwise. It wasn't a bird they had seen, they had spied a sailboat. From then on we knew they hadn't seen a big bird.

This is the end.

This oral history is a clear example of what was likely a sighting of Spanish ships exploring the West Coast of North America. Their patterns of thought on what they could not explain are indicative of their traditions and what would ultimately be their most grievous vulnerability. On October 3, 1775, the Spanish schooner *Sonora*, with Lieutenant Bodega y Quadra at the helm, hove into view of what is now Bodega Harbor, crossed Bodega Bay and dropped anchor in Tomales Bay. The encounter was peaceful, with the natives approaching the ships in canoes adorned with gifts for trade. The exchanging of gifts between Miwok and Spaniard was amicable and would be one of very few peaceful encounters the natives would experience. The following day, the Spaniards departed the bay to continue their journey to Monterrey.

No known written accounts are found to explain if there were visits by ships or foreigners between the years 1776 and 1792. But then sixteen years after Lieutenant Bodega left the Sonoma coast, the Miwok were visited by two ships. The names of these ships are unknown but were presumed to be English because descriptions explained that the men wore red. These ships stopped at Bodega Bay about the first of October 1792 to take on fresh supplies and asked the Miwok to get cattle for them. One year later, in October, the *Chatham*, captained by George Vancouver, stopped at the bay. Its British captain was informed by the natives that the Spanish were in possession of a part of the bay. Between 1800 and 1808, some foreigners stopped at Bodega, but if contact was made between resident and visitor, it is not known. Up to 1808, all reports of contact between the natives and foreigners reflect no hostile behavior from each or toward each other, and some semblance of social intercourse took place, to the satisfaction of all involved.

On January 8, 1809, the Russian vessel *Kadiak*, with Kuskof commanding, anchored at Bodega Harbor and remained until August 29. Friendly relations

were established between the natives and Russians by the distribution of Russian gifts, which led to much trading. Some temporary buildings were erected by the visitors during their eight-month stay. While here, the Russians sent 50 of their 150 Aleut fur trappers overland to San Francisco Bay with their kayaks in search of the pelts of native wildlife. Other members of the Russian expedition, namely 5 or 6 deserters, 2 of whom were "Americans," traveled to the Spanish settlements.

These are the first events giving evidence of any contact between the strangers and residents in the interior of Sonoma County. Granted, there is no direct information of the natives having met or sighted the intruders, but with a large number of Aleuts tramping through Miwok territory, they could not have remained ignorant of the visitors as they made their way from Bodega Bay to San Francisco. During the next year, from August 1809 to September 1810, several more ships visited Bodega Bay, but again there is no record of trade or contact. It is not hard to conjecture that by this time when a native spied a sail, some attempt at trade or gift giving was made. If there were any altercations with any crews, doubtlessly some mention would have been made.

On September 28, 1810, a small American vessel was at Bodega Bay with sixty men who built three huts on shore. This was discovered by one Alferez Moraga from Mission San Jose who visited there that September. Moraga explored to some extent a fertile valley in this region but gave it no name. Again, there is no report of contact by either the ship's crew or Moraga with the Miwok residents. Six months later, on March 4, 1812, the Russian ship *Chirikoff* made its way to Bodega Bay with Kuskov at the command. The

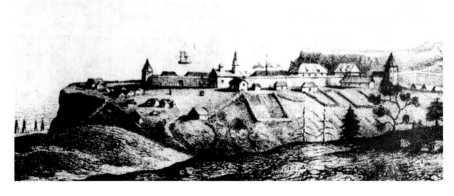

Illustration of Fort Ross and the fenced fields by A.B. Duhaut-Cilly, 1828. *Courtesy of California State Parks,* Fort Ross: The Russian Settlement in California, *Fort Ross Citizen's Advisory Committee, June 8, 1974.*

Russian captain devoted his attention to the conciliation of the natives and to exploring the region around Bodega Bay and inland along the Russian River for twenty-five miles. This was the first penetration by foreigners into the heartland of the Southern Pomo, and possibly it was the first sighting the Wappo had of the white man. The site for a permanent Russian settlement was established eighteen miles up the coast from Bodega at the Kashaya village of Metini, today's Fort Ross.

The Russian acquisition of land for settlement from the Kashaya is of special interest to anyone interested in the Native American. The following quote should be taken cautiously, for obvious reasons. The original author, H.H. Bancroft, in his *History of California*, probably thought the same. Bancroft states:

> *The native chiefs were made friends by the distribution of petty gifts, and there is not much doubt that they made, either now or the next year, some kind of a formal cession of territory to the newcomers. The price paid, according to the statement of the natives in later years…was three blankets, three pairs of breeches, two axes, three hoes, and some beads. Always more or less hostile to the Spaniards and to their brethren under Spanish rule, the natives were indeed glad to have the strangers come as allies and protectors. In later disputes the Russians dwelt upon this cession as one of the strongest elements in their title—so expedient has it always been found in the New World to affirm the natives' right of ownership where the soil could be bought for a song, and to deny it when forcible possession must be taken.*

By September 1811, a fort had been completed.

> *Thus the Russians' cherished plan for gaining a footing on the California Coast was brought to a successful issue, and as yet without opposition either from the natives, whom the newcomers chose to regard as the owners of the country, or from the Spaniards.*
> *The seller of Metini* [Fort Ross] *was Chief Parac.*

But not all was peaceful on the coast between native and newcomer. The Kashaya were friendly and at first came often to the fort. Gradually, the visits, especially by men, became more and more rare. The cause for the decline of visitors was due to the imbalance of the sexes at the fort. Most of the Russian party were men (about 170), and they brought with them only 20 women. The men sought to attract and live with, if not

marry, native women. Animosity rose on the part of the natives to such a degree that an attack was made on the settlement by a Southern Pomo chief soon after the Russians arrived. However, it was easily repelled by a few discharges of musketry.

This is the first incident of a disturbance reported and, if one is to believe the information given, not a usual occurrence at Fort Ross. In comparison to other societies and cultures coming into contact in North America, the Kashaya and Russians were amiable. One Russian wrote in 1818, "The settlers grew well acquainted with Indian habits and living, for frequently when exploring parties were overtaken by darkness while far from the Fort, they accepted hospitality and a lodging overnight in the Indian villages."

Kashaya history, though undated and passed on orally, gives a more complete picture of the temper of the times:

> In the old days people lived at Metini [Fort Ross]. They say that at that time the undersea people [Russians] had landed there. They lived there together close by, having become acquainted with each other.…
>
> Having landed, they built their houses close to where the Indians were. After staying for a while, they got acquainted with them. They stayed with them. The Indians started to work for them. They lived there quite a while.

As this quote mentions, the Kashaya natives supplemented the Russians' working force, with the women being hired to perform domestic work around homes and other labors, while the men were employed to do the more laborious work.

NATIVE VS. SPANIARD

As the Plains Indian would soon enough do and those of the Southwest already had done, the Pomo and Wappo were beginning to become aggravated enough to do battle with the transgressing forces of the white man. These white men were the Russians, as already stated, and the Spanish. The causes for hostility were everything from trespassing to theft and slavery.

Every facet of intercourse the natives had with the Spaniards was different than that with the Russians. The Russians came by ship, the Spaniards by horses; the Russians were concerned with business and labor, employing the natives, while the Spaniards were there to conquer and enslave. The natives

were so timid "that when the Spaniards first made their appearance among them on horseback they fled in terror and secreted themselves in the bushes."

The first evidence of the potential jeopardy in which the Spaniards were placing themselves was on November 9, 1821. Captain Luis Arguello had charge of an expedition that proceeded up the Sacramento Valley and then headed west to just south of Clear Lake. On November 8, they came to the Russian River just north of Cloverdale. The padre of the company, Father Blas Oredaz, kept a daily log. He wrote:

November 9—between 10 and 11 resumed march in the same S direction, taking as a guide a gentile who took the direction penetrating the rest of the sierra until arriving at a sublime eminence, from where we saw larger and more dangerous mountains than the ones previously passed and so we remained on high without knowing what means to take. Until having taken stock of the food of which there was enough for only three days and most of the horses remaining dead on the road from much work, scarcity of pasture and difficult passage, it was thought best that the guide should take another direction to go down to a valley in which another ended called Levantolome [Sebastopol], *contiguous to this mountain on whose elevation it was growing dark. The guide took this means of fleeing by some very steep gorges with bushes. But God be praised, some of the soldiers started after him as soon as they saw him and overtook him, punishing him. Already the shades of night were falling and in this difficult situation in which we found ourselves…the horses could scarcely keep their feet on account of the many leaves of trees with which the ground was covered. At 10 at night we arrived at the aforesaid site of the valley where we passed the night. After having* [turned] *in the direction from whose top could be seen with all clearness the Russian presidio.*

November 10—this day began our retreat toward the [south] *for the Asistencia of San Rafael, following the valley of Levantolome that is contiguous the mountain that we left today with the title of Buen Retiro. In this valley we found the remains of a skull of one of the Christian neophytes of San Rafael that was killed by the gentiles and carried there for the purpose of burial. We also set free the last gentiles who served as guide. After two leagues of our retreat we saw a multitude of gentiles on the opposite side of the arroyo that runs at the foot of the mountain, whose rancheria has the same name as the valley, gathered in a thick wood, of which situation they had made use to utter their accustomed cries with gestures of attacking. But as soon as they recognized the troop they had not the daring to come out of the*

site they had chosen, although some more intrepid put themselves in a position to throw stones, notwithstanding the troop was formed to see if they were out to the plain and to punish their boldness, and having known their timidity the commander ordered us to keep on our way back, and at six in the afternoon arrived at a spring to which the name San Jorge was given, situated in this same valley where we made camp for the night.

The next day, they passed Petaluma and stopped at Olompali in Marin County. The above entry gives a good example of what the Pomo thought of trespassers in general. Two years later, on another expedition through Marin and southern Sonoma Counties, Padre Jose Altimira and twenty-one others spent the night of June 26, 1823, in the vicinity of Petaluma with ten Petaluma Miwok hiding from their enemies of Levantolome, the Kainomero of the Sebastopol area. In 1824, a mission at the town of Sonoma was started as a result of this expedition.

The pages are few with facts and history between 1824 and 1833 as far as conflicts are concerned, even though there was much activity at the mission with the creating of a town, agriculture and mission. In 1833, at least two attempts were made by intruding Mexicans and their allies to establish a hold, though a small one, on the plains between Sebastopol and Santa Rosa. A newly arrived lieutenant, Mariano Vallejo, tried to establish a presidio in this area for two reasons: first, to make the Russians aware that Mexico had made claim to the countryside, and second, to provide sanctuary for the invading settlers from the offended Pomo who had been displaced. The presidio lasted one month. Along with the presidio was an obviously feeble attempt at establishing a colony. It lasted less than six months due to a harsh winter and the colonists' refusal to stay in a country of hostile natives.

The next year, 1837, the mission at Sonoma was secularized by Mexico, and the lands with cattle were given to the Indian laborers living there. Those who remained tried to continue living in the mode of the Mexicans. A few succeeded; some lived with the habits of the worst frontier Mexicans. Most Indians dispersed to their original homes.

D.E.L. Chernykh, a Russian farmer at Freestone from 1831 to 1841, wrote that Indians from various tribes throughout the area north of San Francisco Bay "were proclaimed freemen" and "engaged in horse thieving." They would take droves of horses from the Mexicans and plunder. Chernykh noted, "Because of Mexican population scarcity there are up to now no ranchos inland. Fear of Indian attacks forced the Californians to settle close to each other."

Sonoma Mission, photo postcard, circa 1940. *Courtesy of John C. Schubert Collection.*

It was later in 1834 that the first and most serious conflict occurred between the Sonoma County natives and the Mexicans. The Wappo met with a strong force the attempt at infringing on their domain and the kidnappings by Mexicans. A series of bloody battles ensued on the edge of the plains northeast of Healdsburg, an area now covered by vineyards. These were the same Wappo who acquired Pomo land in 1830. The adversaries were Mexicans led by Vallejo, and Colorado was leading the Wappo. Some of Vallejo's subordinates were probably his brother Salvador and Cayetano Juarez.

The Mexicans lost many, but the Wappo lost more, amounting to hundreds by death and capture. Both sides withdrew from the battlefields, the Wappo in the hills and the Mexicans to Sonoma. Because of the severity of the fighting, Vallejo sent a message requesting assistance to Jose Figueroa, governor of Alta California. The governor responded in person, bringing with him a large military force. The Wappo had justly earned their name.

Because of their depleted ranks, the Wappo were frightened into signing a treaty. Peace was made with Daniel, a Wappo leader. The pact was faithfully kept by both sides through the following year. The Mexicans never forgot the keen and stinging defeat inflicted on them by Colorado. Colorado was

probably the war commander and Daniel the treaty maker, much like today's generals and international advisers.

In the midst of this turmoil, a naturalized Mexican, John Cooper, arrived in the country of the Kainomero village Levantolome, north of Sebastopol. He was given a grant of land by Mexico in December 1833, which he named *El Molino*. Cooper wasted no time in establishing peaceful relations with the local Pomo. He followed the pattern the Russians had been using for twenty-two years to coexist with the approximately two thousand Kainomero in the area. Cooper, as early as 1834, placed a considerable number of cattle on his grant and commenced the erection of a mill. He also erected a blacksmith shop and for two years employed an average of sixteen and sometimes thirty or forty Indians on his ranch. The use of employment by Cooper allowed him to reside there through future hostile times.

At the same time, 1834, Vallejo sent two men, Edward McIntosh and James Dawson, to live near and check on the Russians about Bodega Bay. They set up house near today's Freestone and the Pomo village of Keewi. With Chernykh having already lived there three years, these three men undoubtedly had a large source of manpower. Since Chernykh probably paid the natives for work, the other two would follow suit. McIntosh and Dawson were there to spy and not to supply the Mexicans with slaves. This probably accounts for no report of conflict between the Pomo and these two.

Vallejo soon gained by the aid of his militia, and especially by the alliance of the Suisun chief, Solano, a control over the more distant tribes and bands that had never been equaled before.

A VISIT TO THE POMO

On September 10, 1833, Baron von Wrangell, commandant of Fort Ross, made a trip inland to see the Pomo and their valleys, from which he made a written report. They went by way of the Russian River to Santa Rosa Valley and then headed north.

> *Several of the savages not long since made an attack on the nearest to San Francisco Mission* [San Rafael in Marin County] *of the Spanish and plundered it. Such splendid exploits suggested or instilled some esteem for the savages and we agreed to render them the deserved honour to surround us with a guard of honour and arming ourselves with loaded pistols.*

At last coming to a large valley, overgrown with grass, we heard loud singing voices. The interpreters hurried away in advance to recognize if friend or enemy meets us. Our own impatience to see the inhabitants of these lonely places made us speed after our avant garde and in full gallop we all surprised an old woman of these American tribes, gathering some kind of herb corns in her basket plaited from fine roots. From fear she was stupefied, not without difficulty we ascertained that behind the nearest thicket there are living several families of the Americans, who without a doubt had already noticed us at this time and concealed themselves, fearing to fall into the hands of the Spaniards, not seldom riding out to catch the savages to convert them to the Christian faith, and that gathering the corns for food, sung out of her full throat, to disperse and drive off the evil spirits, always obeying the voice, repelling a hundred times in the mountains. Assuring the old woman that her voice did not attract evil intended people, we left her in peace and continued on our ways. The first night we stopped on a considerable collected plain valley between several hills, on the shore of a little river falling in the Slavianka under branched oaks [Russian River]. *The warm mild air, the clear sky, the moonlight night, the bivouac fires and herding of the horses in the high grass, all this presented a picture agreeable to the imaginations and the feeling. The piercing and shrill howls of the jackals disturbed the harmony of nature, but with the beginning of daylight all became quiet and we hurried forward with impatience to reach the famous valleys spoken of in Ross and to meet their inhabitants. Soon the places became wider and enlarged, extended fields with rich vegetable earth, covered with fat grasses, opened themselves one after another, but nowhere even a trace of the inhabitants. Suddenly we perceived on the far edge of the valley a winding stream of smoke; the interpreters and vaqueros concluded that there must be a village of many American natives and with some fear communicated to us this information. The smoothness and spaciousness of the place permitted our whole army out of five nations to unroll by front and gallop with loose bridles so as not to give time to the savages to conceal themselves in the bushes.*

Advancing and near, we behold a wretched miserable tree and not the least sign of the presence of people, further beautiful groves of oaks as an English park were changing with fields of grass, and at last we rode up to the river Slavianka, which during the summer season is dried up in several places. Where we were crossing it or fording it, she was not broader than five fathoms and not deeper than three feet. Arranging ourselves on her left shore in the bushes to dine, we heard voices drawing near to us from the

savages. Closing or shutting out behind ourselves the horses which were left grazing, we sent the interpreters to meet the comers, who it proved were friendly visitors, attracted to come here with the desire to see us. Their number was about 15 men, their wives and children remained in the village nearby. From them we learned that the villains who took revenge on the Spaniards for the violations of the tranquility of these peaceful inhabitants of these valleys by pillaging the mission of the savages, were for the most part white men from the mission of the savages, have placed themselves in ambuscade behind inaccessible bushes beyond the large valley in front, where they are ready to repulse any attack of their enemies. Our guides meanwhile learned that one highly esteemed chief of these American tribes had been at Ross, and being treated kindly by the Russians is at present here in the surroundings: I wished to see him, and asked our guest to inform him of our arrival. The eldest chief chose one young lad as a messenger; this one throwing off his light cover or girdle, taking up his bow in his hands, was lost out of sight in so short a time that we had no opportunity to recompense him with small presents for his willingness to serve. The open, joyful, unanxious outlines of their faces of these savages, and their kind

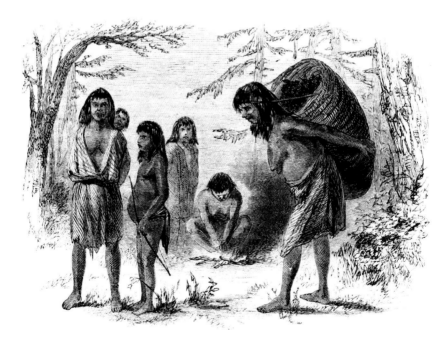

Out in the Mountains, a woodcut of a daily scene in a Pomo village. *Courtesy of* Harper's New Monthly Magazine, *August 1861, "The Coast Rangers," p. 312.*

intercourse pleased me very much; we invited them to visit us in our night bivouac and they promised to find out wherever we would stop. Yet before evening arrived we reached the very largest valley; at the beginning there is not wood or forest, and even like a table, covered by fat grasses, and viewless (immense) in her broadness.

Thus, the commandant entered the Santa Rosa Valley and gave little further notice of the Pomo.

NATIVE DECLINE

The years from 1834 and 1846 were a period of declining numbers and strength for the Pomo and Wappo, while the Mexicans and their allied Indians were increasing up to 1838. But the Wappo, two years after their crippling defeat, were going to have more trouble.

The Kainomero were friendly for some years toward the Mexicans, and apparently "because they returned stolen horses to them, they got into trouble with the Guapos." In late February or early March 1836, the Wappo, in a sudden attack on the Kainomero, killed twenty-two of them and injured fifty. General Vallejo, on appeal from the Kainomero leaders, came to avenge their wrongs. Old battle lines were drawn again. On March 28, Vallejo ordered troops assembled. He advanced on April 1 with fifty soldiers and one hundred natives besides the Kainomero. Salvadero Vallejo, the younger hot-blooded brother of Mariano, commanded one division. Three days later, the Wappo were met in battle. Their position was a strong one, being in the foothills of the Geysers regions. But they were routed and driven back to their villages, where most of them were killed. The Mexican forces returned to Sonoma on April 7, with the familiar skeptical report of "without having lost a man killed or wounded."

Oil painting portrait of Captain Manuel Salvador del Mundo Vallejo y Lugo (1814–1876), age thirty-five years. *Courtesy of Ancestry.com, accessed April 7, 2017.*

On June 7, a peace treaty and alliance were concluded with the chiefs of seven tribes, among them being the Guiliko (the Wappo east of Santa Rosa) and the Wappo of Alexander Valley who had voluntarily gone to Sonoma. The treaty stated:

1. *Vallejo is to deliver to Succara (Chief of the Sotoyomis) weekly eight steers, and two milk cows.*
2. *Succara each new moon is to deliver to Sonoma two strong bears able to fight with savage bulls.*
3. *As a guarantee of good faith Succara is to send his brother Cali-Vengo (Rough Hill) and his sons Ipuy Succara and Calpela Succara to live at the Commandant General's house and to be treated as if they were Russian officers as long as they behave well.*
4. *Succara promises to surrender runaway Indian criminals (robber or murderer) on pain of shooting of relative and non-delivery of cattle.*
5. *Not more than 30 Sotoyomis to Sonoma at a time and must give notice to Vallejo beforehand.*
6. *Wives of Sotoyomis may come to the fort as many as 100 for amusement for trading (no weapons).*
7. *Vallejo shall not invade Sotoyomi territory with armed force without consent of Succara.*
8. *Sotoyomis to deliver all the captured children of Cainameros to Fort Ross and Suysunes to Sonoma within a month (retroactive 3 years).*
9. *For each prisoner brought in Succara shall get a horse.*
10. *Both parties responsible for losses their followers bring upon the other— shall talk over settlement.*

After this treaty was drawn up, each faction gave gifts to the other.

The biggest and most damaging killer attacked in May 1838 when smallpox raged throughout the area. The disease was brought from Fort Ross to Sonoma by a Corporal Miramontes. Natives fell in great numbers; Vallejo thought perhaps seventy thousand died in Sonoma, Napa and Solano Counties. The Pomo of Konhomtara (Sebastopol) died from ten to twenty per day; many funeral pyres burned in the traditional Pomo way.

After the pestilence passed, the number of Indians to resist encroachment on their land was small, so much so that Joaquin Carrillo "established himself on the Santa Rosa Plains and lived alone far from any garrison, in perfect security."

In July 1841, the Wappo were said to be planning a new attempt to destroy the ever-increasing foreigners with their own diminished people. Salvador Vallejo was ready to march against them, but the eventual outcome is unknown.

Fort Ross was sold in 1841 to John Sutter of Sacramento, and the Russians left Sonoma County to the Mexicans and natives. In mid-1845, a raid was made by the Mexican grant owners and their laborers from Sonoma to the region of Fort Ross from Sonoma to obtain Indian "laborers" (*slaves* would be more accurate). This slave expedition was brought to the attention of the Mexican courts because of a quarrel about the division of the spoils. In August, the proceedings in Sonoma were presented before Alcalde (Judge) Cayetano Juarez, a former captain of the local Mexican militia and ex–Indian fighter. It was brought out that several Pomo were killed and 150 captured. Antonio Castro and Rafael Garcia were named as leaders of the party.

Protecting the Settlers, a woodcut of pioneers attacking a native village. *Courtesy of* Harper's New Monthly Magazine, *August 1861, "The Coast Rangers," p. 313.*

The next six years of Indian history are not recorded because of other events. The Mexican-American War in 1846 resulted in California becoming a territory of the United States. Lieutenant Joseph Revere, U.S. Navy, came to Sonoma to raise the U.S. flag and enforce the U.S. occupation of Northern California. During his stay, Revere made a pleasure trip to Clear Lake with a party of eight men. Their return trip was through Santa Rosa Valley, where a certain "Indian Chief" named Pinole Colorado joined them. Revere stated, "We passed the site of an old Rancheria, in a beautiful and celebrated spot by the [Russian] River's side, which we distinguished by the raised earth where its lodges had once stood. Old Colorado informed me that the Spaniards had killed or carried in captivity all its inhabitants."

The party continued and arrived at Pena's Tzavaco Rancho (also known as Chino Rancho), which was a population center of Southern Pomo on Pena and Dry Creeks. Revere continued:

That being the centre of an Indian population, I deemed it necessary to hold [a] talk. A stormy scene ensued. It appeared that old Colorado had accompanied me thus far to make use of my authority to reinstate his tribe in their Rancheria and territory lying in the centre of Chino's [Pena's] Rancho. But as the latter had a grant of the land from the Mexican government, and as I had no jurisdiction in the matter, even had I been disposed to interfere, I of course declined complying with the demands of the Chief. At this Colorado laid all the blame of my refusal to young Chino and insulted him before my face; whereupon, to avoid bloodshed and establish discipline, I had him taken into custody by one of my men, with orders to make him ride on before, and if he attempted to escape to shoot him. He did escape, however, by diving under his horse and making off in the bushes. Bunk [a white sharpshooter] *fired at him, but the Indian made good his retreat, owing no doubt to the clemency of the marksman.*

After peace was declared between the United States and Mexico in 1847, Mariano Vallejo was made Indian agent, and Lieutenant John Brackett, Second U.S. Artillery, was made military commander. Brackett wrote Military Governor Mason in July 1847 that Indians were stealing Salvador Vallejo's stock. Stealing is what the European settlers called it, and from their point of view it was probably so. The begetting of food is probably what the Pomo called it, and it was not dishonest from their standpoint. The custom was for the whites to let their cattle roam free. Brackett simply investigated the matter, with no conclusions.

With the United States occupying all of California, Mason was not able to increase the garrison at Sonoma even though skirmishes between Indian and intruder in Mendocino County to the north resulted in death for the adversaries. In April 1848, Vallejo asked to be relieved as Indian agent and wrote that white settlers should not be permitted to settle on land of the Indians until some arrangement had been effected. In May, there were threats of hostilities by the residents of the Sonoma area because of the possible removal of Brackett's company. The governor did not believe such danger existed and stated that it was not practical to keep the garrison in Sonoma; the people would have to defend themselves. Vallejo was to use his influence to maintain a stable countryside. Vallejo responded that the intruders must be removed, to which Mason informed Vallejo that in an emergency, aid would be sent from San Francisco with ammunition.

The next month, June 1848, Vallejo put his influence to the test. He entered into a treaty with eleven triblets/villages, which was made primarily

to keep the peace on the Sonoma frontier. Some of the groups were Southern Pomo and Miwok of Clear Lake. The treaty stated:

To whomsoever it may concern:
Be it known that we the undersigned chiefs of Tribes and Rancherias in and about the Big Lakes on the Sonoma Frontier of Upper California do solemnly affirm and declare that we are friends with good hearts towards the whites, our powerful friends and neighbors; that we will make no aggression upon them nor their property and if injured ourselves by anybody, we will apply to the proper authorities of the whites for protection and redress.
Sonoma, California
June 1, 1848
Witnesses, M.G. Vallejo, Sub-Ind. Agt.
Jas. A. Hardie, Major 1, NY Regt.
Comdg. Northern District California
Manae X of Atenok, Thayte X of Chiliyomi, Cuyagui X of Tuiiyomi, Shonepoca X of Limaema, Hilali X of Mosliyomi, Namostk X of Tsaysymayomi, Tsapat X of Chitimocmyomi, Tum Tum X of Moguyeacyomi, Calgui X of Holhonpiyomi, Calichem X of Meynimocmayomi, Hutznin X of Lupiyomi.

Though the chiefs signed this supposed "treaty"—actually an agreement—there is doubt they knew what they were signing and what it contained. In actual practice, it never worked. The invading whites ignored it, and the Indian complaints were few because they were ignored in general. Only those incidents that were feloniously malicious by the whites were given attention. If an Indian died because of a Mexican or American, that person was given a reprimand. If a white died because of an Indian, the invaders would mount an expedition, and the results would be death to many natives of several triblets and villages, many of which were not involved.

In 1849, a prime example of this retaliatory behavior took place. Two whites, Stone and Kelsey, were killed near Clear Lake because of their sadistic treatment and starvation of their Indian laborers. The whites in Sonoma mounted a revenge expedition and killed about thirty-five Pomo in a village near Kelsey's Ranch. The commanding officer was relieved and replaced by a Captain Lyons. This captain made another vengeful trek. A large number of Indians were killed at Bloody Island, even though none of the natives were involved in Stone's and Kelsey's deaths. This became known as the Bloody Island Massacre. A detailed story from the Pomo view

of this massacre and another by the same expedition a few days later near Ukiah can be found in Barrett's *Material Aspects of Pomo Culture*.

In 1848–49, depredations of hostile and non-sociable Indians still continued under American rule, with slight change in methods or results of warfare against them. It was at this time that the California Gold Rush started in earnest.

Indian villages of this whole region, being northern Sonoma County and others to the north, were raided periodically for slaves; children particularly were carried off, as there were white men who made a business of it. They would watch for a poorly protected rancheria, surround it and kill off the adults. Then they would take and sell the children in the areas south of Sonoma County.

A slow genocide was taking place throughout California with newly arriving gold miners and hangers-on. The Indian was exterminated; some triblets became extinct under American rule. And all this was to be repeated on a larger scale during the Indian "wars" of the Western Plains from 1860 to 1890.

Chapter 3
NATIVE LIFE AT FORT ROSS

HISTORICAL BACKGROUND: FIRST CONTACTS

The spasmodic and short contacts of the late eighteenth and early nineteenth centuries between European cultures and resident coastal cultures of the Coast Miwok and Kashaya (Southwest Pomo) were peaceful. The meetings took place at Bodega Bay and Bodega Harbor in southwest Sonoma County; these side-by-side locales were used by the foreigners as anchorages because they afforded protection (for European ships) from the ocean storms. Because fresh water, meat and wood were secured from the neighboring coastal lands, it was during these times of foraging that contacts between Europeans and indigenous residents occurred.

Historical records show the first possible contact was in September 1790, when Englishman James Colnett of the *Argonaut* was forced to drop anchor between Bodega Head and Bodega Rock because of storms. He obtained wood to replace spars and fresh water along the shore of Bodega Harbor. As far as it is known, Colnett made no mention of the natives residing in the area or any contact with them. Anthropological studies by Alfred Kroeber establish the fact that the Bodega area had been well occupied by Coast Miwok up to and including 1790. However, if any type of contact was made, it was not known.

The next two ships that stopped at Bodega were also English. In March 1793, the *Jackal* and *Prince Lee Boo*, commanded by Captains Alexander

Stewart and Gordon, stopped for water. Again, histories report no contacts except that the Miwok relayed to their neighbors the arrivals and departures of ships. This information finally reached the Spanish, who were then located at San Francisco. The fact that the English were using Bodega Bay prompted a strong reaction in the Spanish, and they set forth to establish a settlement at Bodega, taking possession of the area. Three ships were sent from Baja California and one land party from San Francisco.

On June 2, Lieutenant Juan B. Matute, the commander in charge of founding the proposed settlement, arrived at Bodega Bay. On July 16, Salvador M. Valdes dropped anchor. Matute was confused as to where to erect the first buildings. The confusion lay in the fact that the name Bodega was switched in copying maps, and the description of the area did not coincide with the information he was given. He sent notice of his befuddlement to San Francisco. By July 23, he had received no answer, so both ships weighed anchor. In their recordings, however, they made no mention of the natives.

Meanwhile, in response to Matute's message, Lieutenant Don Felipe Goycoechea left San Francisco on August 5 with ten men and one sergeant. Five days later, he arrived at the harbor. His diary of this expedition does expose a few facts about the two Spanish mariners and their intercourse with the native residents. The natives told him Matute left some chickens and pigs with them. In exploring the area, he found the barracks erected by Matute at the entrance of the port. Goycoechea wrote:

> As it was now very late at night and there was much fog and I was short of firewood, I asked the natives for some of this and for water. They gave me some of what the ship had left. We passed the night without unsaddling all the horses, as the people from such settlements had come to visit us. They were much delighted and asked me to remain another day so that all the natives roundabout could see our horses. I told them that I would not leave very early, so as to allow time for them to come, but that I could not stay all day because I had nothing for my animals to eat. They offered to go fishing for us for something to eat, gave me two bunches of feathers and some stones out of which they make beads. I presented them with some beads and some of what we carried to eat, and with this they were much pleased.

Apparently, Matute's one-month stay and Valdes's eight-day visit were at least non-hostile toward the Miwok, and the reverse was probably true, as evidenced by the natives' behavior. The same could be said of Goycoechea.

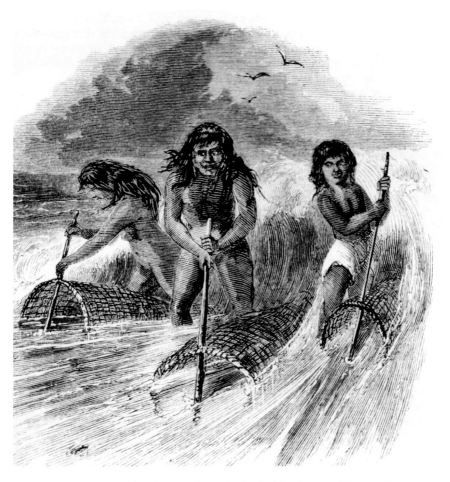

Beach Fishing, a woodcut of native men fishing in the Pacific. *Courtesy of* Harper's New Monthly Magazine, *August 1861, "The Coast Rangers," p. 315.*

The third and last ship to assist the settlement was under the command of Felipe de Eliza with fifty-seven men and officers. He arrived on August 9, and since no one was present, save for the Miwok, he left on the morning of August 10, the same day as, but long before, Goycoechea arrived.

Some fourteen years elapsed before the next known visitors came to Bodega Bay. Captain Oliver Kimball, carrying hunters of sea otters, anchored the *Peacock* on March 5, 1807. Kimball was under a Russian contract, and Vasili P. Tarakanov, representative of the Russian-American Company located in Alaska, was on board to direct the hunting. Crude houses were built on the beach, and twelve *bidarkas* (an Aleut kayak) were

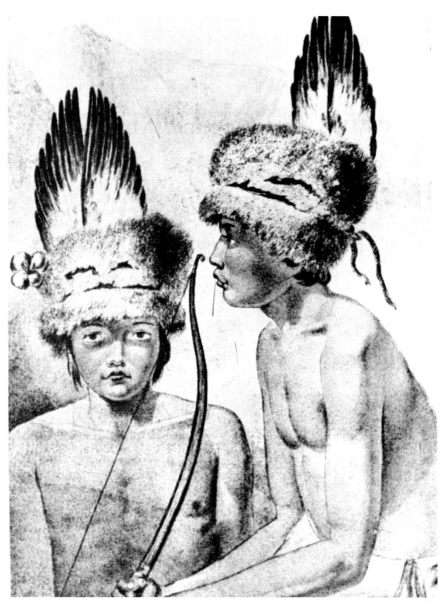

Watercolor painting of Pomo native man by M.T. Tikhanov, 1818. *Courtesy of California State Parks,* Fort Ross: The Russian Settlement in California, *Fort Ross Citizen's Advisory Committee, June 8, 1974.*

sent up and down the coast. Their stay of over two months, until May 15, allowed opportunity for the ship's crew of fourteen men, if not the twenty-four Alaskan native hunters, to establish some sort of intercourse with the Miwok and their neighbors to the north, the Kashaya.

The following year, 1808, the American captain George W. Eayers "touched at Bodega" and left. Again, there was no report of contact.

At the end of December 1808, the Russian captain Efim Petrovich (Petrov) of the *Kadiak* arrived. He had with him "150 Indians, 20 women and 40 Russians." The "Indians," all Aleuts, were hunting sea otters. The territory surrounding Bodega Bay was carefully explored, and "friendly relations were established" with the Miwok and Kashaya by gift giving. Temporary buildings were put up, which sufficed for their eight-month stay. They left in August 1809.

It was mainly the results of these hunting expeditions and explorations of Tarakanov and Petrov that prompted the Russian-American Company to return in 1810 for two months and again in 1811 for four months.

There was another expedition by the Spanish to Bodega Bay under the command of Gabriel Moraga during September–October 1810 to check on the activities of other European powers about the Bodega area. Unfortunately, a search of information and data available has failed to reveal any more than already stated.

RUSSIAN ATTITUDES TOWARD NATIVES

The combination of all encounters between European and Kashaya-Miwok was a positive element toward the establishing of a Russian settlement. While the struggle that took place between Russian and Spaniard over land occupation and trade does not concern us here, the overall attitudes of the newcomers were vastly different. The behavior of the Spanish toward the coastal native was one of condescension. The Russian and English attitudes, while difficult to describe, were (from the facts given) not hostile. The reason for the absence of war-like encounters between native and Russian later was due to native amiability and policy in the articles of the Russian-American Company:

Since the main object of the Company is hunting of land and marine animals, and since therefore there is no need for the Company to extend its

sway into the interior of the lands on whose shores it carries on its hunting, the Company should make no efforts at conquest of the peoples inhabiting those shores. Therefore, if the Company should find it to their advantage, and for safety of their trade, to establish factories in certain localities of the American coast, they must do so with the consent of the natives, and use only such means as would help retain their good will, avoiding everything that may arouse their suspicion about encroachment on the independence.

Such a regulation was necessary because of the conflicts between the company and the Tlingit of British Columbia, where the company had been carrying out extensive hunting for furbearing animals.

The oldest known photograph of Fort Ross, taken in 1865. Photographer unknown. *Courtesy of John C. Schubert Collection.*

The Russian occupancy of Alaska was under stress for the want of foodstuffs and supplies. To maintain their hold on that territory, they had to resort to some means other than being a drain on the treasury of Czarist Russia. In November 1811, Ivan Kuskov, along with ninety-five Russians and forty Aleuts, took possession of Bodega Bay and Harbor. He "purchased" that land from Point Reyes to Point Arena and three leagues inland. The much-quoted price paid was three blankets, three pairs of breeches, two axes, three hoes and a few beads to the Indians under Cucuoan (Kashaya).

Another chief, Valepila, raised the Russian flag over his possessions as a measure of protection "from the Spaniards."

Finding Bodega Bay had only enough wood to construct a few warehouses, not a community, the decision was made to erect the main settlement some fifteen miles north of Bodega at the Kashaya village of Metini. To further good relations with the natives, the Russian leader continued gift giving and gave small silver medals to be worn as necklaces inscribed with "The Allies of Russia." It is written that Bodega and the warehouses were guarded by the Miwok chief Tuituye and his people, and in turn, they were not molested by the Russians.

EMPLOYMENT AND WAGES

The Russians, in order to continue their pursuit of furs and self-sufficiency, predictably approached and hired Kashaya as a source of labor. No more than 100 were employed at any one time for Fort Ross, the settlement at Metini. This amounted to about 7 percent of the total Kashaya population. But there were never more than 150 present at the fort.

Clothing was used as exchange for labor. Necklaces, jackets, breeches, blankets, blouses, vests and items to adorn the body were preferred above all other things. The "other things" that were used as remuneration by the Russians were foodstuffs such as wheat and beef rations, plus boarding at the fort and the various farms started by them. Boarding was a house in which a family or families resided during inclement weather. At Peter Kostromitonov's farm near the mouth of the Russian River, this building was fifteen feet by forty-two feet. A similar structure was located at Bodega Harbor, and there is a strong possibility of one existing at Igor Tchernykh's farm near Freestone.

The amount of payment was considered fair, at least in the European eye. It fluctuated as the natives saw fit, at times demanding much of their labor and at other times little.

The exposure to alcoholic drink was accepted only to a minor degree.

Kashaya traditional construction needs did not consist of lumber or trees felled by hand but trees that had fallen by nature. Redwood bark was peeled and then used in their cone-shaped shelters. The wood from trees shattered from falling was put to use also. However, due to the expanding settlement, the first labor performed by the Kashaya for the new residents was the felling of timber to build Fort Ross. Later, the probability of Kashaya men working in felling timber is greater because of Russian shipbuilding at Ross and the export of lumber.

The herding of cattle and other animals was a job the Kashaya and Miwok filled (as well as the Russians and Aleuts), and the Natives eventually became accomplished riders.

The most common tasks were related to agriculture. At first, the fields of rye, wheat and other cereals were planted on plains near the seashore but, due to the damp conditions, resulted in small harvests. The fields were moved inland to the hillsides away from such moisture. The areas chosen were rocky and accessible only by foot or horseback. Neither horse nor ox worked or plowed well because of the rocky hills. The natives were employed to remove rocks from the uncultivated lands and till the soil with spades. No more than twelve Russian colonists were employed at such labor at any time. The harvesting was done also by the Kashaya and Miwok. They gathered and stocked rye; wheat was harvested, put up in sheaves and carried down on sea lion skins to threshing platforms at the farm centers. The Russian Tchernykh wrote, "Under this method of threshing, in order to finish 1,000 sheaves per day, it is necessary to use 100 to 200 horses and 20 to 25 Indians who take turns to drive the horses."

During his visit to Fort Ross in 1834, Russian manager in chief Baron von Wrangell wrote, "At the time when they reap grain Indians gather in the settlement for commensurate pay, or by necessity, when there are few hunters, then they forcibly collect as many Indians as possible, sometimes 150 persons, who for 1.5 months are occupied without rest in Company field work."

Other agricultural products were grown; root crops, vegetables, wine fruits and fruit-bearing trees were extensive. When one considers the ability of the natives to learn new ways, it is not hard to conjecture that besides harvesting, they also planted.

Other fields of endeavor engaged in by Russians, using Aleut labor, were the gathering of animal products from nature. The Aleuts, besides otter hunting and sealing, engaged in fishing and whaling for oil and grease. For approximately fifteen years, the Farallone Islands, located twenty-one miles west of San Francisco, were occupied by Russians or their employees. From 1812 to 1818, one Russian was in charge of six to ten Aleuts or natives on the islands. They were engaged in drying big meat and feather and egg collecting. Seals and sea lions were trapped for meat, fat and furs. Domestic animals were raised at the farms and fort for the usual products they produced: sheep for wool and mutton; pigs for pork; cattle for beef, butter, cheese and leather. The herders for these animals were either Russian or Aleuts. An Aleut was put in charge of tanning hides, sheepskins and chamois.

In the field of industry, the Russians made bricks of local clay, grindstones, chinaware, barrels, wheels and other goods.

KASHAYA AND MIWOK TALENTS

The contemporary Russian writers unanimously state that the Kashaya and Miwok were used only for manual labor by the Russians, as stated by Kostromitonov: "They appear stupid only because of their immoderate laziness and lightheartedness. However, they need only once observe some work that is not too difficult or complicated, in order to copy it immediately."

By Captain Pavel Nikolaevich Golovin: "The Russians have few horses or mules and for most of the work used oxen or Indian labor."

By Fort Ross Manager Potechine: "Most of the manual labor around the fort was done by the Indians."

By Commandant Aleksandr Rotchev: "They return each spring in a greater number than the preceding year to cultivate our fields."

And by Petr Aleksandrovich Tikhmenev: "The natives become indispensible for harvesting grain, but learned the value of their labor so well that they hired out to the newly arrived Americans in the vicinity."

These writers limit us because they present only one viewpoint, and research has revealed that no other peoples, other than Russians, made any note of Kashaya-Miwok labor forces.

SPENDING HABITS

Of those few natives who worked for the Russian settlements, nearly all disposed of their earnings in the same fashion: gambling. One Russian writer put it plainly: "Gambling was everything to them."

The same harmonious note is struck by all the Russian writers who made notice of this habit: "Their only object in getting a thing is to be able to gamble it away again….Their love of games is so great that after a hard day's work at Ross they will sometimes play till four o'clock in the morning and then return to work without sufficient sleep."

Rotchev noted: "One day one would meet a Native dressed in everything the person had and the following day be bare of everything." He concluded, "This rapid change was brought about by their devotion to the practice of gambling." The Russians tried to slowly make Kashaya and Miwok change their habits to the Russian style of living through enticements and rewards, but they steadfastly refused to change. The only thing this approach by the Russians accomplished was to diminish the "adverse feeling toward the whites among the natives of the tribes which frequented Bodega."

CONCLUSIONS

The settlement of Fort Ross attracted surprisingly few Kashaya over a period of thirty years, from 1811 to its end in 1841. As previously stated, approximately 7 percent at the most were present. There was no mention by either the then-Russian recorders or present-day scholars of whether women were present to do labor or if children were ever involved in any form of work. Some women of Kashaya did marry Aleuts.

Payment was made in clothes and jewelry, possibly because of the colors. Sonoma State University's anthropologist David Peri stated that the magnesite beads that had the most color (those with whites, reds and blacks) were more valuable than those of one color or light in color. This same standard could be applied to clothing as payment; those with the most color were valued highly by the Kashaya. But this is only conjecture, as the Russians would surely have noted it.

The reason for such a low percentage of native population present might be due to the influence of the Kashaya leaders and shamans, possibly practicing isolation from the Russians. This type of influence occurred

when Annie Jarvis, shaman of the Kashaya from 1912 to 1943, practiced segregation of her people from the whites, and only the catastrophe of World War II changed it.

Gambling is still done in the native way today, using two marked and two unmarked bones for guessing games. The medium of change in the Russian period was clothing. This was also the case when American journalist and historian Stephen Powers visited the Kashaya in 1876. He noted that a few coins totaled to eight dollars, but there was "a large hatful of strings on shell money, and an immense heap of clothing and blankets."

The Russian influence and pressure to change the Kashaya and Miwok way of life to one of "foresight and the attraction of property" was slight on the surface, but the natives, in their own way, applied values to property.

Chapter 4

STAND AND DELIVER!

Stagecoach Robberies in Dry Creek Valley

S TAND AND DELIVER!" are the infamous words declaring a stagecoach
holdup is in progress. These words are, by tradition, attributed to Dick
Turpin in late seventeenth-century England. In the United States, stage
robberies are generally attributed to the Old West. Sonoma County was not
immune to this form of thievery. When and where the first Sonoma County
stage was demanded to halt and "throw down the box" is unknown. But
what is known is that several holdups occurred in the late 1860s. For the
most part, these robberies were perpetrated by a lone gunman, and seldom
did the robber commit the deed twice in this county. The robberies were
generally a singular event in all aspects.

However, early in 1871, the norm changed in Sonoma County's wine
country. The first band of "professional" road agents presented themselves
at about 3:00 a.m. on a cold February morn. The plodding of four horses,
the rattling chains from their hitches and creaks from an approaching coach
could be heard. Bill Polley was the man holding the reins of the stage on
its fifteen-mile run from Healdsburg to Cloverdale. Suddenly, two men
grabbed the lead brace of Polley's horses, while a third shoved two barrels
of a shotgun at his body. A demand for the Wells Fargo express box was
complied with immediately. The seven passengers were not molested. The
drivers were released by the two cohorts, and the stage sped on through the
night to Cloverdale.

Deputy Sheriff William Reynolds and John Thompson in Healdsburg
were informed of this crime and gave quick pursuit. They found where the

NEW ARRANGEMENTS!!

THE CALISTOGA, HEALDSBURG AND CLOVERDALE

STAGE LINE!

Will run on and after this date, as follows:

Leave Cloverdale daily (Sundays excepted) at 5 o'clock A. M., ticketing passengers through to San Francisco, where they will arrive at 7 o'clock P. M. the same day; Leave Calistoga at 1:30 P. M. and land passengers from San Francisco in Cloverdale at 7 o'clock P. M. the same day, connecting with Stages at HEALDSBURG for SKAGGS' SPRINGS, and the GEYSERS, and at CLOVERDALE with stages for

Ukiah City, Kelsey, Lakeport, Big River, and all towns on the Coast
OF MENDOCINO AND SONOMA COUNTIES.

FARE:

CLOVERDALE to SAN FRANCISCO,	$5 00
SAN FRANCISCO to CLOVERDALE,	5 00
Healdsburg to Calistoga,	2 00
" " San Francisco,	4 00
" " Sacramento,	7 00
" " Marysville,	8 50

TICKET OFFICE in San Francisco at the office of the S. F. PACKAGE EXPRESS COMPANY, 311 Montgomery street, and also on the Steamer NEW WORLD. The

TRAVELING PUBLIC

Will find this the Quickest and Pleasantest Route between CLOVERDALE and SAN FRANCISCO.

FISHER & COOMBS,
Healdsburg, June 23, 1870. PROPRIETORS.

"RUSSIAN RIVER FLAG" PRINT, HEALDSBURG.

Left: The series of stagecoach robberies suffered by Wells Fargo and Co. spurred other stage lines in the region to revise their schedules to eliminate night travel. The Calistoga, Healdsburg and Cloverdale line announced its new arrangements in a widely distributed handbill on June 23, 1870. *Courtesy of John C. Schubert Collection.*

Below: An example of the Wells Fargo cash box. *Courtesy of John C. Schubert Collection.*

outlaws had tied their horses for a holdup. Tracking the trio a mile and a half across the hills to a canyon, they found where the gunmen had rifled the box for $1,375. The lawmen followed the hoof prints from there twelve miles north to where the trail was lost on a country road. When Wells Fargo received the news of its loss, a reward was posted: $250 for each rogue caught, plus a quarter of the recovered money.

The county remained quiet for the next several months. No clues turned up, no suspicions were made toward any men. The days became long and hot in Alexander Valley. It was mid-July 1871. On a late, warm evening, Amasa Morse was rein-checker on the Robinson stage from Healdsburg. About three and a half miles south of Cloverdale, a man with a shotgun hailed him to stop and "throw down the box." At the same time, three men stepped through the darkness and seized the horses. Morse quickly did as he was told and pitched the chest into the road. The four bandits disappeared into the darkness with the box, and Morse charged for Cloverdale. Later, the strongbox was found about fifty yards from the scene minus $402. Again, Wells Fargo offered a reward: $250 for each culprit and half the money recovered.

The local constabulary was not idle. The search for evidence and information was tediously made. On July 15, three days after the second stage robbery, Deputy Reynolds arrested John Houx (Hoo) of Cloverdale and transported him to Santa Rosa. Later that same evening, about midnight, Reynolds was awakened and told that another suspect, Lodi Brown, had just passed through Healdsburg. Reynolds jumped out of bed and summoned his brother John and they quickly headed toward Geyserville. It wasn't long before Brown heard rapidly approaching horses. He spurred his mount to top speed. The strange trio galloped through the darkness, pursuers and pursuee. Not a word was spoken. Chase was given for several hundred yards. Since Brown was the fleetest of the three, Reynolds couldn't close on him. Finally, the deputy drew his gun and yelled to Brown, "Halt!" Brown checked his mount and wheeled it about with a double-barrel shotgun at the ready: "Who's with you?"

Reynolds stood his ground with gun still pointed at Brown: "Me and my brother. We're putting you under arrest for robbery." John also had his muzzle at the man. The night suddenly got close. Surveying the situation and deciding against the odds, Brown surrendered his shotgun, pistol and knife and was taken back to Healdsburg.

The two suspects were booked into the county jail. Lodi Brown, born in Missouri, was a farmer who lived near Cloverdale. He was five feet,

four inches, of medium build with light complexion, light brown hair and gray eyes. His face was triangular with broad forehead, sharp straight nose, small mouth and chin. Brown resided on the family farm with his father and his brother, John. He was not married and not known to have a girlfriend. No description has been found for John Houx, but he did live in Cloverdale with family.

On July 24, Justice W.H. Toombs of Healdsburg arraigned the two and conducted a preliminary hearing. District Attorney Overton examined Deputy Reynolds as witness for the people. Reynolds was then cross-examined by attorney Ross, counsel for the defense. At the conclusion of the hearing, Justice Toombs declared there was no evidence the two defendants ever did or would rob a stage. The case was dismissed and the prisoners released. The freed men headed home to the Cloverdale area.

On a Monday night approximately two weeks after the release of Houx and Brown, a coach driven by a Mr. "Doc" Curtis with excursionists from San Francisco headed toward Cloverdale and points north. Dark figures stepped out of the black roadside and ordered the driver to halt. When commanded to give up the express box, Curtis told the robbers this was not the regular stage, so they told him to go on. Soon after, the regular stage passed unmolested on to Cloverdale.

Because of the suspected operations of Houx and company in the area, parties sending money and valuables from Point A to Point B resorted to concealing their parcels on freight and other wagons, hiding them in sacks, among bundles, harnesses or in food containers. Three days passed after the stop of Curtis's coach. It was Thursday night, August 10. Sandy Woodworth was handling his own stage on a regularly scheduled north-bound run. He was about three miles south of Cloverdale when a shape stepped out of the night shadows with a shotgun and ordered him to stop: "Throw out the express box."

"I won't do it," barked Sandy. He crouched low on the seat and snapped the reins hard on the horses' backs. The stage jerked into the night as the robber pulled the trigger, but only the cap fired. Woodworth made good his escape up the dirt road to Cloverdale. He skipped the next evening's trip but resumed his regular schedule two days later.

The local newspapers were now starting to complain in their columns. Wrote the *Russian River Flag*, "A determined, systematic effort should be made to provide a home in the State's hotel for those enterprising fellows, so that they may no longer endanger their health on the road in the night air."

Deputy Reynolds and the local constables were trying to reap as much information as possible to solve the armed robberies and snatch the culprits. One of the local journals said, "Officers and citizens have been diligent in endeavoring to capture the robbers, but as yet no arrests have been made nor has any clue been found which is likely to lead to their apprehension."

Obviously, any stagecoach driver or passenger who traveled the Healdsburg-Cloverdale high road at night must have done so with apprehensions and trepidation. The warm summer days in Alexander Valley continued. The stages rumbled and rattled over the dusty county road day and night. An uneventful week passed quietly.

On August 16, the Cloverdale stage left Healdsburg as scheduled at 9:00 p.m. with Sandy Woodworth again handling the ribbons. Inside, the coach was filled to capacity with eight passengers, among them Meyers F. Truett of Truett's Station. Up on top with Sandy were Wells Fargo messenger Charley Upton, H.P. Benton of Ukiah, B.S. Coffman of Round Valley and W.S. Chapman. The stage was about a half mile below Asti when four men with shotguns jumped from hiding into the starlit road. Upton showed his. Gunfire ripped the night as shards of light flashed. Truett emptied his shotgun from inside the stage, hitting one rogue. Shots were rapid from both stage and road. The horses bolted into full gallop. Yelling and gunfire continued until the stage was out of range. The sounds of the last shots rolled across the dark valley and then slowly faded as the careening coach raced for Cloverdale. At the scene, Houx and his gang members took count of themselves and found Rattle Jack severely wounded. Houx, "Big Foot" Andrews and Lodi Brown were unhurt. Quickly, they mounted and rode through the night-cloaked woods with their wounded buddy. Rattle Jack died and was buried somewhere in the country west of Cloverdale.

Portrait of Meyers F. Truett (believed to have planted the first vineyard of the present-day Truett-Hurst Winery), circa 1870s. *Courtesy of John C. Schubert Collection.*

Inside and on top of the stage, the passengers surveyed those who were injured. All those shot were outside.

Benton was mortally wounded. Driver Sandy had one ball of 00 shot enter his cheek and exit near his ear; two more went through his hat. Coffman was hit by nineteen shots, eleven of which went into his body. A mile and a half up the road, Woodworth stopped at Truett's ranch, where the wounded and others got off to attend them. Then Woodworth, with his injured cheek, raced with the remaining passengers on to Cloverdale and notified local authorities. Back at Truett's, it was discovered that the elderly lady who had been a passenger inside the stage and was now nursing Benton's wounds was his mother. Her care was for naught; her son died the following day. Coffman survived his many severe wounds due to his doctor's professional attention.

Uproar swept the north county. The strongbox held less than $1,000. The passengers could not confirm who fired the first shot. Many thought that since Upton was a Wells Fargo agent and was prepared to shoot, he may have fired first and caused the shootout. The local news media was irate:

> *The public will hold Wells Fargo & Co. responsible for this blood. It was culpable folly to provoke an attack on a stage-load of inoffensive men, women and children from a band of desperate highwayman* [sic]. *To imagine that these outlaws would be intimidated by the sight of a shotgun or two, or to suppose that in case of a fight the robbers, skulking about on the ground in the dark, could be worsted by one or two men on such a plain mark as a stage, and to attempt to carry out either one of these ideas, is criminal ignorance and a reckless exposure of the lives of innocent passengers.*

Wells Fargo offered a $1,000 reward for each culprit arrested and convicted for murder. Another paper reported that Wells Fargo offered $4,000 (!), while the state promised $1,000. The investigators and the county lawmen, meanwhile, were following up on information and leads, real and imagined. The shootout was enough to make one stage company change its schedules. W.H. Forse, owner of the Cloverdale & Arcata Stage Line, converted all his runs to daytime trips, starting September 1.

Since Rattle Jack had been killed and it seemed that resistance was the plan of action by the stage lines, Houx was convinced to fill his ranks with more freebooters. He and the three original members—Lodi and John Brown and Big Foot Andrews—voted in a man named Billy Curtis. Later, the brigands accepted, at separate times, four more rogues: a Mr. Jones, Willie Samsel, Alf Higgins and Tom Jones (unrelated to Mr. Jones).

The following weeks were quiet. Stages passed to and fro along the trace unmolested day or night. Time drifted into September with no trouble from Houx and his gang. Summer faded into autumn and October, and still there was no word from Sonoma County Sheriff Potter or Wells Fargo about any developments in the case. But tranquility was too good to last. October 10 became another date marked by robbery. It was on the toll road (today's Highway 128) ten miles above Cloverdale, known as the McDonald Grade in Mendocino County.

At about ten o'clock in the morning, Houx and Curtis stopped George Carter driving the Ukiah Stage. Both bandits were disguised; one was wearing a military overcoat and a slouched hat to cover his face, and the other was covered with something like a sheet. One made the demand for the treasure box, while the other stood at the leaders. The remainder of the gang waited back out of sight. The five passengers, two from Ukiah, took no part in resisting the desperados, nor were they molested. Driver Carter complied with the order. The command to proceed was given in Spanish, and Carter willingly followed the order.

The lawmen tracking and investigating found the chest minus $185, but the crooks left $740 plus papers and letter. From there, the trail grew cold. This robbery was very different from the others: it occurred in broad daylight on a well-traveled road in Mendocino County, and only two men were seen.

Narrow roads through rough and sparsely settled country in Mendocino, Lake and northern Sonoma Counties left stagecoaches vulnerable to attack from highwaymen in the 1860s and '70s, as seen in this photo postcard. *Courtesy of John C. Schubert Collection.*

Most important, money (a whole packet) bound for Mr. Thatcher of Sanel was left behind. Again, in the public's mind, the law officers were short of results, short on information and short on ideas. It appeared nothing was going to change for the better and the public conveyances would ever be prey to the whim of the holdup artists.

The *Mendocino Democrat* newspaper reported that on November 5, the stage for Ukiah was well protected:

> *Parties anticipating there might be the usual call for Wells Fargo and Co.'s box were in attendance on the route to give any callers proper attention. No call was made, hence horses and stage passed along as smoothly as a boat on unruffled sea. Report has it again that the highwaymen had made preparations for action and had sent an individual onward to Healdsburg to reconnoiter and see whether or not the ground was clear and safe.*

Deputy Reynolds, with his brother John and other lawmen, finally made a move. It was Thursday evening, November 9, a month after the Ukiah stage holdup. Mr. Jones and Houx were in a Cloverdale saloon with Curtis. Curtis called for drinks on the house. As Houx lifted his glass to his lips, Mr. Jones stuck a pistol into Houx: "You are arrested. Throw up your hands or you're a dead man." Houx's hands went high. He was searched, and three guns were found on him. Curtis and Mr. Jones (in truth Steve Venard, notorious detective of gold country origin) were working undercover for Deputy Reynolds. Curtis was the bandit who actually took the $185 from the Ukiah stage and deliberately left the bundled $740. The Reynolds brothers, waiting outside town, got word that Venard had collared Houx and quickly joined him. The three went, with Houx in cuffs, and traveled to Tom Jones's house and arrested him.

With two bandits under guard, the trio and several others went after more quarry. They next wanted Big Foot. They proceeded to the house of Houx's father to get information. Leaving guards around the house, the Reynolds brothers approached. A large dog in the yard set to barking, which brought a man to the upstairs window; Deputy Reynolds recognized John Brown. A few moments later, Brown, armed with a twin-barrel shotgun, six-shooter, Derringer and Bowie knife, flung open the front door. The deputy slowly stepped forward, saying, "I have to disarm you." Brown backed into the house. John Reynolds told Brown, "Stand still—don't be afraid." Brown hesitated. John quickly moved forward and removed his weapons. Lawmen, 3; Bandits, 0—two more to go.

Thursday evening turned into night, but the lawmen proceeded with their job. The law agents, three prisoners and a company of guards headed to the upper end of the McDonald Grade, past the scene of the latest stick-up in Mendocino. There, the deputy left his brother in charge of the guard and the three captives. The rest of the hunters swung south. Because of the detective work by Venard and Curtis, it was known that the gang's hideout was somewhere in the canyon lands of the Dry Creek headwaters.

As the men rode on, the night gave way to the pale dawn of Friday morning. The band continued a short distance up trail and dismounted. They secreted their mounts with a guard, and quietly, Deputy Reynolds, Curtis and Venard proceeded up the canyon, under laurel and oak, around buck brush—always maintaining cover. After traversing three hundred

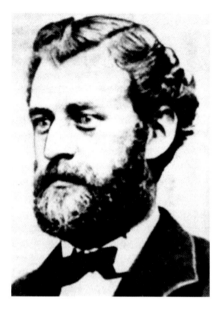

Portrait of Steven Venard, famed road agent killer and America's most fearless lawman of the California Gold Rush era. While the majority of his manhunts took place in the Sierras, his presence was briefly known here in Sonoma County. *Courtesy of the Truckee-Donner Historical Society.*

yards, the men removed their boots and carefully stepped off the last mile barefoot. When they arrived, it appeared no one was at the outlaw cabin. The lawmen withdrew about two hundred yards to a nearby wooded creek and concealed themselves. They knew the rogues were in the habit of watering their horses at this stream. They waited only five minutes before the last of the quarry rode up. Bandit Lodi Brown, as expected, headed for the creek with his mount. As he came down the bank, the men sprang. For the second time, Brown was looking down the barrel of Reynolds's gun. They muffled him as he was pulled to the ground and tied. One down, one to go.

The last one to be collared was Andrews. "Where's Big Foot?" asked the deputy. "He's up the canyon about 300 yards at the camp," Brown answered, "getting dinner. You can't take him unless you kill him." The deputy told Brown in no uncertain terms that he was going back up the draw with them to take Andrews, and if he saw Big Foot, he was to drop down in the trail. Reynolds didn't want Brown to add to the extremely tense situation.

The foursome made their way back up to the cabin, but Big Foot was nowhere to be seen. They waited a minute and then backed down the trail, where they devised a plan to get Big Foot to come out to them. Deputy Reynolds and Venard secreted themselves along a bank. Curtis, guarding Brown, fired Brown's gun, and then the captive was made to call out, "Bill, I've killed a big buck—come and help me pack him in." Would the plan work? So far every capture had been successful: four prisoners and nobody hurt.

Reynolds tensely waited with his body frozen to the bank and his heart pounding. The wanted man came down the trail. When he was opposite them, the deputy and Venard arose. "HALT!" Four guns were aimed at him. Protected by Venard, Reynolds stepped toward Andrews. "Unbuckle your gun—drop it and step back." "I pass," said Andrews, and did as he was told. Five robbers, five captured, not a shot fired. Not bad for twenty-four hours' work.

The three lawmen, with their two captures, retraced their trail, gathering up the rear guard and mounts. On reaching McDonald Grade, they collected the three other prisoners and their guard and all headed to Ukiah and the nearest jail. A wagon was procured, and the Houx Gang was loaded aboard. At 11:20 p.m. that Friday, the wagon and guard pulled into Ukiah. The cry went out: "Robbers!" A rush of people poured into the main street in front of Ukiah House. The guards raised shotguns and pistols, commanding, "Back" and "Stand back!" And "back" it was; the crowd gave space. Many in the crowd recognized members of the gang as past residents and visitors in south Mendocino County.

The gang of five were lodged in the county jail. The telegraph wires clicked the message of what had happened that night to Cloverdale, Healdsburg and Santa Rosa. At 11:00 a.m. on Saturday, a crowd gathered again as the wagon was loaded with shackled men. Houx sat quietly and thoughtfully wrapped in a cloak, Lodi Brown was despondent, John Brown made a feeble attempt at whistling and Tom Jones just sat. William "Big Foot" Andrews was the coolest; he remarked to someone standing near the stage that it was going to cost them to keep the irons on him.

Quickly, the stage moved out of the town and down the road. Guards armed with shotguns and revolvers galloped alongside and at the back. All were bound for Santa Rosa. On the stage seated alongside the driver was Jones (in the middle) with Charles Cook, former Wells Fargo agent, on the outside (the shotgun seat). Inside on the middle seat were Houx and John Brown. On the back seat were Andrews and John Reynolds. On the way

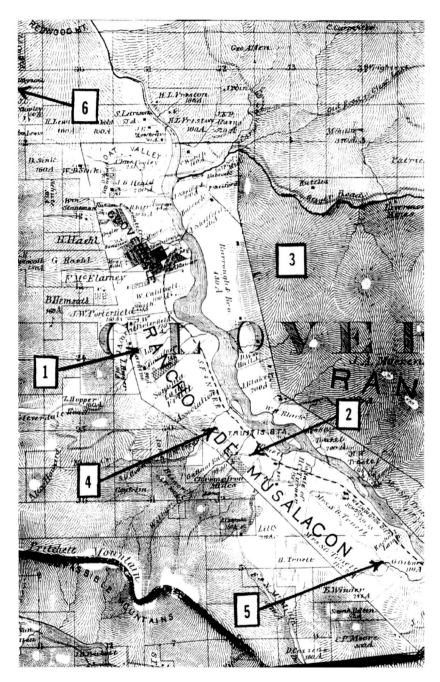

This detail of a survey map of the Russian River near Cloverdale has been marked to show the location of the Houx Gang's holdups, numbered in the sequence in which they occurred. *Courtesy of John C. Schubert Collection.*

south, William A. Samsel, a sixth and minor member of the outlaw gang, was arrested. Only Rattle Jack was not to be found, as he had been killed.

In Cloverdale, another crowd turned out. Some friends of the gang made threatening talk of freeing them. If there was ever a chance at freedom, this would be the best place—Cloverdale, with home, family, friends and familiar territory. The armed party kept moving. Other people in the crowd prevailed, and no attempt was made. Most people had bad feelings about the outlaws, and it was feared the prisoners would not survive if a gunfight erupted.

The mixed band of lawmen, guards and prisoners kept heading south down the main county road to Santa Rosa. They passed the scenes of their crooked endeavors on the way. The last was the site of the bloody shootout nearly three months before. The travelers arrived in Healdsburg and stopped at the Sotoyome House for an afternoon meal. Again, a large crowd gathered to see the shackled notorious men. By evening, the prisoners were safely lodged in jail at the county seat.

Now the five men had to face justice. All were initially liable for the murder of Benton. An examination of the evidence led the district attorney's office not to file charges again Tom Jones, and he was released. While the Houx Gang fretted away behind bars, District Attorney Barclay Henley was building a case against them. He realized that a charge of first-degree murder would be a weak one at best. Henley figured if he could get a negotiated plea to a lesser offense, it would be better than to go to jury trial and all be found not guilty. Accordingly, he talked with Houx. If Houx would turn state's evidence, all charges in Sonoma County would be dropped. Houx accepted and agreed to squeal against his former partners.

Defendants Lodi Brown and William Andrews were now facing execution. John Brown was charged with robbery. Negotiations were initiated between the district attorney's office and defense counsel J.J. May. On January 5, 1872, in district court, the Honorable Lewis Ramage arraigned John M. Brown on two counts of robbery, to which he pleaded guilty. The plea was accepted by the judge, and he sentenced the defendant to three years in state prison. John Brown entered San Quentin on January 19, 1873, and was released on August 12, 1874.

Judge Ramage next arraigned John's brother Lodi and Big Foot Andrews on one count each of second-degree murder. Their case was continued for six weeks to February 22, when they entered pleas of guilty. The judge accepted the pleas, and four days later, on February 26, he sentenced both defendants to thirty years each at San Quentin. Three days later, they entered prison.

While in prison, Andrews was an average inmate. On February 26, 1876, a fire erupted in the prison's workshops. Andrews helped in controlling and suppressing the flames "in a meritorious way." On May 30, Governor William Irwin reduced his commitment by five years. Three years passed. On August 6, 1879, a prisoner named John McGuire slit Andrews's throat. William "Big Foot" Andrews was thirty-seven years old when he was killed.

Fortunately, Lodi Brown had an uneventful stay at San Quentin. In early 1878, he petitioned Governor Irwin to be pardoned from his sentence. Accompanying the petition were various letters from family and close friends declaring that "he is a nice boy,"

Portrait of the honorable Judge Lewis Ramage. *Courtesy of John C. Schubert Collection.*

"he was young at the time, only 20 years," etc. Word of Brown's bid for freedom reached northern Sonoma and southern Mendocino Counties. Letters and petitions with 1,250 signatures in opposition to such an event were submitted to the governor. Wells Fargo sent letters to Irwin adamantly against any release whatsoever:

> *From early youth Brown was a reckless, violent and lawless character, strong willed and quick minded with the capacity and resolution, as well as the disposition to carry out the promptings of a depraved nature....*
> *Previous to attaining his fourteenth year he shot at a man upon a race course, and in an altercation a year or two afterward, stabbed another man.*

Despite the public outcry, Governor Irwin pardoned Lodi Brown on January 6, 1880, but with the provision that he leave the state. He left.

William A. Samsel had been arraigned for his deeds in county court on the charge of conspiracy to rob. No matter what Houx said to the authorities, Samsel refused to change his original plea of not guilty. His case was heard before a jury, which, on April 8, 1872, returned a verdict of not guilty.

Now to the leader of the rogues: John Houx appeared in district court on February 28, 1872, and had all charges lodged against him in Sonoma County

Valentine's letter to Governor Irwin arguing against a pardon for the robbers, dated June 1, 1878. *Courtesy of John C. Schubert Collection.*

dismissed. He was not released, however. Sheriff Crockett of Mendocino had two warrants for Houx because of the robbery in his jurisdiction. Houx remained in Sonoma County jail through April. Arrangements were made by Crockett to keep him there because it was thought the Ukiah bastille "was not safe for him." Houx was taken to Ukiah on June 4, 1872, for arraignment in county court on charges of conspiracy and robbery. Through his lawyer, he asked for a change of venue to Sonoma County because most of the witnesses for his defense resided there and it would prove a hardship for them

CHANGE OF TIME!

CLOVERDALE AND ARCATA

STAGE LINE!

Fare Reduced

AND

Speed Increased!

ON and after SEPT., 1ST, 1871, and until
further notice—I will run a daily line of Concord
Coaches

CARRYING THE

**U. S. Mail and Wells, Fargo &
Co.'s Express.**

Leaving Healdsburg every morning Sundays ex-
cepted, at 5.30 o'clock. Returning leave Ukiah
every day, (Sundays excepted,) at times as well as
will run leaving at Cloverdale and Healdsburg with
stages for

**Santa Rosa, Petaluma, Calistoga,
Anderson Valley, Big River and
Clear Lake.**

Stages for Little Lake, Sherwood Valley, Cahto
and Long Valley start from Ukiah on Mondays
Wednesday, and Friday after the arrival of the
stage from Cloverdale. Returning leave Cahto
Tuesday, Thursday and Saturday at 6 o'clock
a. m.

W. H. FORSE, Proprietor.

The Cloverdale and Arcata line announced its daytime-only schedule in this advertisement, which appeared in the *Mendocino Democrat* on September 1, 1871. *Courtesy of John C. Schubert Collection.*

to come to Ukiah. The motion was granted. His case was filed in county court at Santa Rosa. From this point, the case of *People v. John Houx* ceases. No further record exists in court films or newspapers. No disposition has been found. Jail? Or freedom? Houx is recorded as being in the Sebastopol area in 1875, occupation: farmer.

The Houx Gang was made up of mostly local people who banded together to execute their deeds. They did not roam far from Cloverdale to the holdup locations. The gang never asked passengers on the stages to hand over valuables; their sole endeavor was to get money from the Wells Fargo treasure box. The foiled holdups were due, in part, to Sandy Woodworth's determined noncooperation. Those were the only occasions firearms were discharged.

The influence of the Houx Gang in the area was enough to make one and probably two stage lines change their time schedules. This influence also extended to private parties. They turned to means other than stagecoaches to move money and valuables. The reputation of this band of rogues spread throughout the north coast of California. The crowds that formed after the word spread in town that the shackled outlaws were coming give mute testimony to their notoriety.

The reputations of other infamous bands of robbers from other parts of the country are greater for all the opposite reasons or elements. These far-ranging gangs had spread their reputations. They were known killers and basically arbitrary in their slaughter. For the most part, they stayed banded, and the individuals were not all from the same immediate area. The other extreme would be a wide-ranging lone gunman with unloaded weapon, leaving notes at the scene.

The end of the Houx Gang did not signify the end of stage holdups. These crimes continued well into the end of the century in Sonoma County.

Chapter 5

AN AGRICULTURAL LEGACY

Tobacco Growers of Sonoma County

Tobacco growing in early California was relegated to small plots for individual use. Sonoma County was not different. Near the end of the 1800s, interest in tobacco cultivation grew so that between 1900 and 1910, serious commercial enterprises were established in Sonoma County.

After the gold rush of 1849 slackened, other immigrants joined the former 49ers in settling other areas of California besides the Mother Lode country. The area north of San Francisco—Sonoma and Marin Counties—was one of them. Some of these people came from the tobacco-producing states of eastern America. They brought knowledge of tobacco cultivation and used it to raise tobacco for personal as well as small commercial use.

When the War Between the States took place, tobacco supplies to the west were reduced. This turn of events put the western grower in a better position to raise a cash crop. The U.S. government, recognizing this situation, created five tax collection districts in California in the year 1862, with Sonoma and Marin Counties occupying District 4. In each district, all cigar factories (in some cases "factory" meant one person) were issued a factory number, which was put on every container of tobacco for sale.

After the Civil War came to an end, more immigrants came west. The 1880 U.S. Census, Agriculture Section, shows how much the war and immigration affected tobacco growing in California:

Year	Yield (in pounds)
1850	1,000
1860	3,150
1870	63,809

To further promote this industry, in 1874, the California Department of Agriculture printed *Tobacco in California*, a thirty-two-page booklet on how to grow tobacco from seed to curing. Although tobacco products were present, it did not become an important commodity in everyday life until the mid-1870s. Nearly 100 percent of the consumers were men, and most of these were laborers.

SONOMA COUNTY DEVELOPMENT

It was during this decade—the 1870s—that Sonoma County's lumber industry boomed. The woods were populated with fallers, suglers, teamsters and millworkers. At the same time, railroads were pushing north from San Francisco through Marin into Sonoma County heading for communities. With them came more laborers.

Towns sprung up in local mining regions of the county, bringing in more laborers and consumers. Every town had one retail location that sold tobacco in at least two forms, cigars and pipe tobacco, and probably a third: chewing. An incomplete list of tobacconists that resided in Sonoma County during the mid-1870s shows:

Petaluma
H. Barth—cigar maker
M Basch—cigar maker
H. Schierhold—cigar maker

Santa Rosa
J. Fitzgerald—cigar dealer
S. Hamburgh—cigar maker
J. Kurlander—cigar maker/dealer
Wright & Williamson—cigar makers/dealers

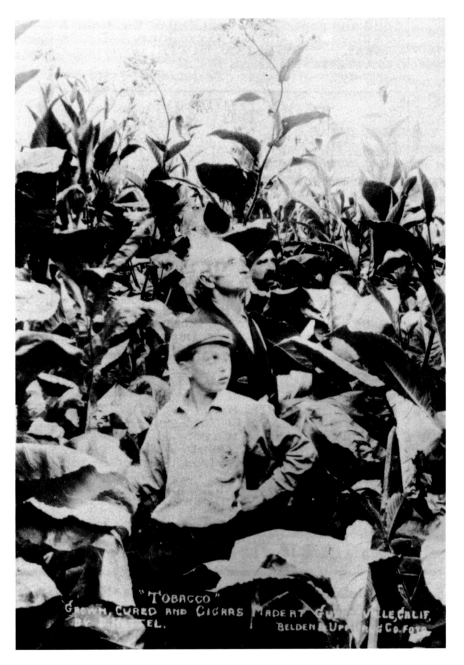

The home of El Bonita tobacco. Guerneville tobacco growers (*left to right*) Jack Hetzel, Dave Hetzel Sr. and Mr. Ewing in one of the fields of Dave Hetzel Tobacco in 1915. *Courtesy of John C. Schubert Collection.*

A newspaper ad for J. Kurlander's Store and Manufactory, circa 1885. *Courtesy of John C. Schubert Collection.*

Three brothers named Korbel came to the redwoods three miles from Guerneville to start a lumber mill. Besides lumber, they also cut wood for their cigar box factory in San Francisco. In 1880, they cleared some of their land of stumps and planted about an acre in tobacco. They were not satisfied with the result of this effort, so this acre and more were converted to grapes. The Korbels decided well.

In Sonoma County, the 1880s was a period of growth in tobacco interest and plantings. In 1885, the Pomona Grange of Windsor entered some tobacco in competition at the San Francisco Mechanic's Institute Fair. It won a silver medal for "Best Display of California Leaf Tobacco." The same grange won a two-dollar premium at the Sonoma and Marin District Fair for "Best Leaf Tobacco Exhibit," also in 1885. A check of grange records does not reveal who grew the leaves.

By 1889, the number of cigar makers in the county increased. A partial list indicates:

Duncans' Mills, 1
Guerneville, 3
Healdsburg, 2
Petaluma, 6
Santa Rosa, 5

There were probably also cigar makers in Cloverdale, Sonoma and Sebastopol.

Still, most of the tobacco was brought in from outside the county. Serious tobacco growing for commercial purposes and possibly to compete against tobacco imported from outside California began in the 1890s. David Hetzel of Guerneville had several acres planted. David Richardson grew some at his Santa Rosa residence, and Walter Allen of Kenwood had an acre with tobacco.

In 1897, the *Santa Rosa Daily Democrat* reported, "Many farmers of Sonoma County are experimenting with small acreages of tobacco this year. Some have planted as much as five acres."

In 1898, Thomas Brown and the Ferguson brothers, all of Hilton, planted several acres with Key West and Havana varieties.

Interest in tobacco cultivation increased further in 1899. Mr. C.H. Vander Lunder of Santa Rosa grew plants and had cigars made from the leaves. T.H. Brock of the Piner District west of Santa Rosa grew the Persian variety leaf. In November, Guy Skinner of Santa Rosa shipped five hundred pounds grown on his ranch to Berkeley.

The *San Francisco Call* reported that Hetzel of Guerneville was quite successful with the Havana leaf. He had been growing and making cigars for twenty-two years. It was his only occupation, unlike others who raised nicotiana as a supplemental crop.

CLOVERDALE

In 1901, several men assembled a business titled Hermitage Tobacco Company. It was incorporated with the total of 28,020 shares, selling for one dollar per share. The three largest shareholders were A.N. Ahrens, with 11,500 shares; J.M. Hartman, with 11,500 shares; and G. Hartman, with 1,000 shares. The principal place of business was San Francisco, but the principal location of the industry was Cloverdale.

By May 1902, the company was becoming stable and productive. Seventeen laborers from San Francisco were setting out plants for the season. In June, the company officers and shareholders came up from "The City" by train to Cloverdale to look around for a warehouse site. The town's welcome for them included a brass band at the station and a parade of the visitors into town. They were fêted at lunch and speeches were given, but no site was selected.

In September, a petition was passed around Cloverdale's businessmen to secure money for purchasing a location of Hermitage in town. The company had established about seventy-five acres of tobacco on upper Dry Creek southwest of Cloverdale.

The 1903 season started with the 1902 crop being made by Ahrens into an order of cigars. These were shipped to the Frankenberg Company in San Francisco. Frankenberg was impressed with the quality and asked Hermitage

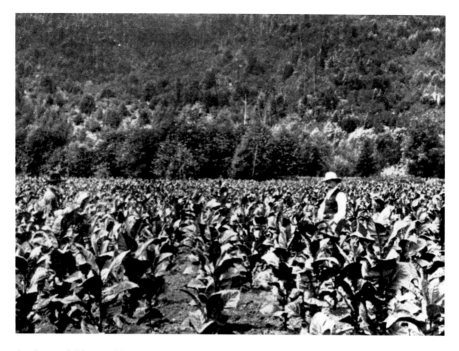

A tobacco field near Cloverdale, California. The man is unknown, photographed by Shaw, circa 1886. *Courtesy of John C. Schubert Collection.*

Tobacco Clearance Sale

Commencing today I will have a Big Tobacco Clearance Sale, at which great values will be given.

Seven-Up Smoking—1 lb. tins, including a Fine French Briar Pipe, only........60c

Fine Cigars—Just the thing for Christmas for a gentleman friend, per box...50c to $10

A. N. AHRENS
MANUFACTURER.
West St., - CLOVERDALE

Made in Cloverdale.

Buy from your home manufacturer and you have a guarantee of securing white labor goods. These brands are becoming more popular every day:

Herald, - 10c
Three for 25c

Sonoma, - 5c
6 for 20c; $4 per hundred

Girl from Frisco, 5c

A. H. AHRENS
MANUFACTURER
West St., - CLOVERDALE

Newspaper ads for A.N. Ahrens; at far left, a clearance sale, circa 1887; left, cigar varietals, grown in Cloverdale, California, circa 1910s. *Courtesy of John C. Schubert Collection.*

for more. Ahrens eagerly complied—he bought leaf wrappers at $2.25 per pound to complement his own leaf.

In mid-April, tobacco seedlings were being transplanted from seed beds into the company's acreage by local labor, a task that continued into May. Continually pressed for laborers, manager Ahrens hired local women and girls to do factory work. On the average, tobacco workers earned a little less than a dollar a day.

This year of 1903 saw more fields planted in tobacco because of the success of Hermitage's 1902 crop. On the Eckhart Ranch, forty-three acres were converted to tobacco. A transplanting machine operated by Frank Gore was supplied with seedlings by five workers. When planting was done at Eckhart's, the machine was joined by a new one at the company's Oat Valley acreage north of Cloverdale. Here, a five-acre parcel was roofed over with light canvas to hopefully create a better environment for the young plants.

Promotions were made for the Hermitage Tobacco Company in the *Cloverdale Reveille* by announcing "Tobacco Shares for Sale." This advertising campaign ran from early May through July.

Also contributing in part to the company's reputation were other ranchers around Cloverdale. Using seed from Ahrens's stock, small acreages were planted by Charles Black, O.P. Fleckner, George Hall and John Turner. Some of these plantings were expected to give three crops.

During the summer of 1903, the weather did not cooperate with Ahrens's endeavor. The first cutting of the crops started the first of August and finished about mid-month. The harvest was light at the company's Oat Valley farm; the ranchers fared slightly better. Though three crops were expected, only two reached maturity, the second harvest totaling less than the first.

Ahrens and company survived 1904, though nothing is noted. It appears a crop was grown that year, as Hermitage put up seventeen thousand pounds of leaf to public auction in July 1905. This 1904 harvest sold at an extremely low price of three cents per pound to a San

Oliver P. Fleckner, mayor, poet and one-time tobacco grower. *Courtesy of John C. Schubert Collection.*

TOBACCO SHARES FOR SALE

Five hund. ⏤ ⏤ares of stock in the Her-
mitage Tobacco Company, at 30 cents per
share. Address

R. A. Spencer,

Cloverdale.

Newspaper ad for tobacco shares for sale from R.A. Spencer, circa 1887. *Courtesy of John C. Schubert Collection.*

Francisco firm. Some of the leaf was of good grade, but most of the tobacco was below average quality.

About 1907, the Hermitage Tobacco Company failed for some reason that has not yet been discovered. However, it is known that Ahrens continued his tobacco endeavor as a private operation thereafter. His cigar brands were the Herald for ten cents, the Sonoma for five cents and the Girl from Frisco for five cents. The Herald was made from Cloverdale leaf tobacco, as were likely the latter two also. After the closing of the company, another cigar, La Flora de General Ahrens, was probably made from purchased leaf. From 1910 to 1915, Ahrens advertised only one brand: La Floridad.

Chapter 6

A History of the Sonoma County Sheriff's Office

The history of the Sonoma County Sheriff's Office began prior to California receiving statehood. In fact, when California became a territory of the United States after the Mexican-American War in 1847, the state was under control of military law. The vast countryside that started north of San Francisco Bay and stretched to the Oregon line and west of the Sacramento River was declared the Sonoma District. The district agent was a gentleman by the name of Mariano Vallejo, and the acting sheriff was one Thomas M. Page.

The headquarters for the Sonoma District was located in the small village of Sonoma. It remained there until all county offices and government were moved to Santa Rosa sometime between 1854 and 1855.

After California gained statehood, the area of jurisdiction was eventually reduced to what constitutes present-day Sonoma County, in addition to the southern part of Mendocino County from Ukiah and Big River south. It wasn't until March 1859 that the boundaries of Sonoma County were changed to what we have today.

During these early years, Israel Brockman served as sheriff. Appointed in 1849, Brockman would eventually be elected to his post and serve until 1854. Benjamin Snoddy and John Reynolds served under Brockman's command, and in 1852, they became the first sworn deputy sheriffs on record.

The first jail in Sonoma County was located on General Vallejo's property in Sonoma. It remained operational from 1850 to 1853. Considering the building was constructed of adobe, jailbreaks were common, despite the fact

Left: Mariano G. Vallejo, early 1850s. *Courtesy California State Library, Sacramento.*

Right: Israel Brockman, Sonoma County's first sheriff, served from 1850 to 1855. *Courtesy of Sonoma County Sheriff's Office.*

that inmates were oftentimes kept in chains. Inmates used various methods of escape, including lock picking, filing bars and tunneling, while some prisoners simply walked away. One night in 1852, the notorious Sarabouse d'Audeville escaped after cutting off his leg irons. The soon-to-be executed d'Audeville left two men sleeping and a letter of farewell on the table. He was the third prisoner under a death sentence to escape from this jail.

In her book *Santa Rosa—A Nineteenth Century Town*, historian Gaye LeBaron relates one of the first documented hangings to occur in Sonoma County. It occurred in the spring of 1854 when a mule rustler by the name of Ritchie was accused of absconding with a band of mules. Some of the animals belonged to Captain Hereford, who lived on Santa Rosa Creek, and two were the property of another valley settler, Mark Tarwater. Ritchie was tracked down, arrested and brought back to the old Carrillo adobe. Several Santa Rosa settlers opposed his immediate hanging, which was considered the customary punishment for the times. James Bennett, the Bennett Valley pioneer and soon-to-be legislator, was rumored to be among the men appointed to escort Ritchie to Sonoma City, which was still the county seat. The next day, Ritchie's body was found hanging from an oak

General Vallejo's old jail, Sonoma County, 1851. *Courtesy of Depot Park Museum.*

tree on Joe Hooker's property in Agua Caliente. The grand jury convened, but all participants who showed up for the inquest wore sprigs of oak in their buttonholes and refused to testify.

A new bill was passed that authorized a vote concerning the removal of the county seat. As a result of the passing of this bill, an election was held in Sonoma County. On September 6, 1854, election poll results showed 716 to 563 votes favored moving the county seat from Sonoma to Santa Rosa. Santa Rosans staged a victory celebration that lasted for two full days.

The county's third courthouse at Sonoma (or the building briefly utilized as such) was scarcely mentioned in record and apparently had no relic. December 13, 1854, marks the first documented plans of an official courthouse and jail. When the county seat was moved to Santa Rosa, a jail and courthouse were built on the northwest corner of Mendocino Avenue and Fourth Street. During the summer and fall of 1855, the courthouse/jail was built for $22,107.23 and included a lower level with space for the sheriff's office, jail and judge's chambers.

In 1856, A.C. Bledsoe was elected sheriff. He only had six deputies, three of whom were jailers. During this time, deputies were sworn in only as needed and served specific jobs, such as law enforcement, tax collecting, jailer, prisoner transport to San Quentin and janitorial services. Other deputies would serve an entire year and then have to be sworn in again to

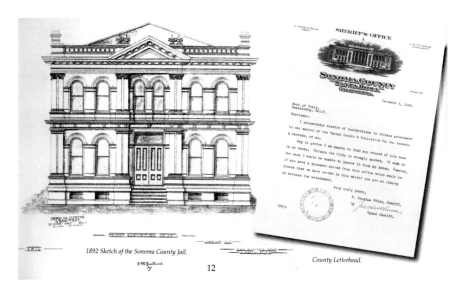

Sketch of Sonoma County Jail from 1892 and the county letterhead. *Courtesy of Sonoma County Sheriff's Office.*

serve for another year at the sheriff's pleasure. Deputy Jacob M. Gallagher was the first permanent jailer and held this position from 1856 to 1861. A contemporary of Gallagher, Deputy Nalley, was sworn in as the first recorded bailiff.

The first few decades were a period of growth and stabilization of Sonoma County's government. In the mid-1850s, problems included lynchings and later a squatters' war at Bodega Ranch that involved mercenaries from San Francisco. Luckily, no hostilities erupted, there were no shots fired, negotiations were conducted and the mercenaries went home.

At the beginning of the Civil War, a large segment of the population in the county was sympathetic with the South. This created a lot of political tension in the county. As a result of this tension, Sheriff Bowles had twenty-three sworn deputies in the early 1860s. During another squatters' war in the Healdsburg area, a standoff occurred between Sheriff Bowles, his two-hundred-man posse and sixty armed squatters. One of the posse was shot and killed by a squatter; however, the squatter was not held accountable for the death. This same thing happened to a deputy at Stoney Point while executing a court order, and the shooter again was not held to answer for the killing. These were the first two men to die while acting on behalf of the Sheriff's Department.

In the mid-1860s, there was a hanging for a murder, which was the only execution in Sonoma County. The murder was documented with the following historical quote:

> *On February 7, 1865, Mrs. Ryan was brutally murdered by her husband Michael Ryan, by striking her on the head with a pick. They had been residents of Santa Rosa but a short time and lived unhappily together, the husband being addicted to dissipated habits. On June 29th he was arraigned before Judge Sawyer and sentenced to death, this being the second conviction of murder in the first degree, which had taken place in the county since its organization. The murderer was decreed to pay the extreme penalty of the law on the 17th of August, but in the meantime a stay of proceedings was granted upon motion of a new trial. He was hanged on March 23, 1866, within the jail yard of Santa Rosa—the only execution which, up to the present time [1879] has occurred in Sonoma County.*

With the maturing of the sciences, law enforcement adopted new tools; the telegraph was used extensively, and the implementation of "mug shots" came about in the late 1860s. Like today, deputies investigated robberies, assaults and homicides. The difference between today's offenders and yesterday's was that a great majority of the past culprits were tramps in every sense of the word: non-resident, homeless, down-and-outs, transients. The only similarities were the homicides. A great majority of the parties involved were county residents who knew each other.

In February 1871, Sonoma County had its own gang of stagecoach robbers, which worked along the main road from Healdsburg to Ukiah. They were known as the Houx Gang and consisted of John Houx, "Big Foot" Andrews, Lodi Brown and "Rattle Jack." Rattle Jack and a stagecoach passenger were killed during their fourth holdup, and several other passengers were wounded. With a concerted effort by Sheriff Potter and Wells Fargo, a Wells Fargo agent went undercover. After the sixth robbery, the law went to work arresting the gang that by then had grown to five members. They were apprehended in various locations in the north county. Even though armed, not a shot was fired by either side. John Houx spent about a year in prison and then was paroled, Big Foot was killed in prison and Lodi Brown was paroled and left the state. The remaining two were released—not guilty.

As stated previously, deputies were sworn in for one year or less and re-sworn for a new year. With such hiring practices, it would be difficult to be a career lawman. However, one deputy, Edward Latapie, was able to work up

the ranks and was elected sheriff. He had first been sworn in as a deputy in 1859 and was elected to the office in 1872. He retired in 1876.

In 1876, the third lynching occurred. However, this event was different than the previous two. Charles Henley, fifty-seven years old, had a habit of letting his hogs run wild up around Bidwell Creek, much to the irritation of one of his neighbors, James Rowland. It finally happened one too many times, and Rowland retaliated by capturing and keeping Henley's hogs. Henley went looking for them (accompanied by his shotgun) and finally found the wayward swines on Rowland's property. An argument ensued between Rowland and Henley, which came to a sudden end with a shotgun blast killing Rowland. That night, Henley rode into Windsor and surrendered himself to a deputy sheriff. Henley was held for a month at the county jail. Word spread about the death, and on the night of June 9, 1876, nightriders went to the home of Jailer Sylvester H. Wilson on Fifth Street. Terrorizing Wilson's family, they took Wilson down to the jail and forced him to open Henley's cell. As four masked men grabbed him, Henley cried out, "Oh Lord boys, spare my life!" Those were the last words he said. Quickly gagged, he was trussed up and taken to Gravel Slough (west Roseland District) and lynched from a tree along the bank. A reward went out by Sheriff Wright for $500 for the capture of the perpetrators. It was later increased by $500 from the board of supervisors and again by $1,000 from the California governor. No one was ever arrested, and Henley's widow eventually claimed her husband's body. This was the first time a suspect was taken from a Sonoma County police agency by force. It would happen again.

In the mid-1860s, the county jail was designed to hold approximately ten inmates, with a maximum of thirteen. In the late 1870s, there were twenty-two prisoners, which required an extra jailer. Everything had reached its maximum. For over seven years, the grand jury and the sheriff requested and pleaded with the board of supervisors for a new jail, or if not a new jail, then at least an extensive renovation. The grand jury responded with the following statement in 1877: "The jail is clean as possible under the circumstances, but the stench from the [privy] is so great as to render it unfit for the confinement of human beings."

Inmates were given two meals a day (8:00 a.m. and 3:00 p.m.) at a cost of $0.35 per day. The guard was paid $1.50 per day; this was not the jailer. The purpose of the guard was due to the in-house count, which was currently twenty-two. The grand jury of 1878 wrote, "The jail is neat and clean but very unsafe." Every grand jury up until 1882 said basically the same thing.

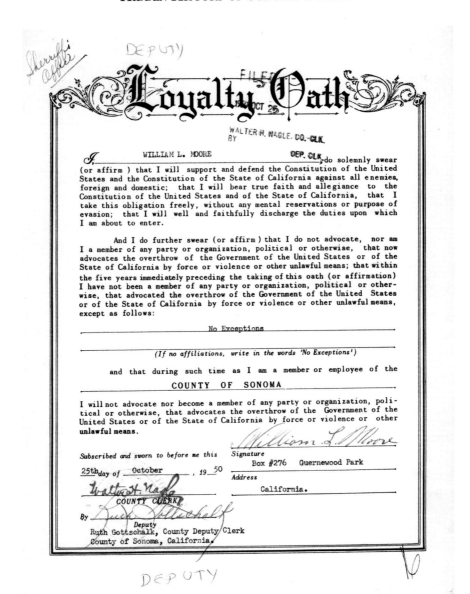

Original copy of the Loyalty Oath of Deputy William Moore, taken October 25, 1950. *Courtesy of John C. Schubert Collection.*

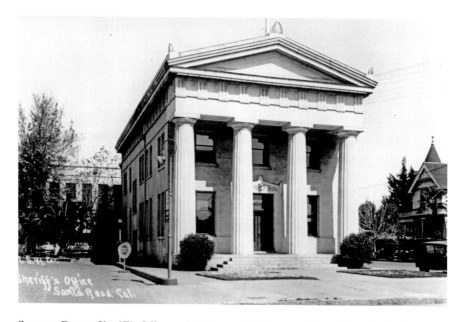

Sonoma County Sheriff's Office and Jail located in downtown Santa Rosa, 1925. *Courtesy of Sonoma County Library, History Annex, call number ANNEX PHOTO3557.*

Finally, the board of supervisors decided that all county offices were to be in one building and agreed to have a new combination courthouse and county offices built. As a result, the seat of county government was moved across Fourth Street to the plaza in the center of town. It was finished in 1885. The sheriff's office and jail were in the basement. The office had three rooms: one twenty-one by thirty-five feet, the second fourteen by twenty-seven feet and a storeroom nineteen by twenty-one feet. The height of the walls was twelve feet (the shortest in the building). The jail section was thirty-eight by fifty-nine feet, with twelve iron cells seven by seven feet and three five by seven feet. The entire jail was lined with iron plates. With the establishment of a new office and jail, the supervisors officially wrote a new menu for inmates:

Jail meals for prisoners—
Breakfast: ½ loaf of bread, ½ lb. steak, potato, coffee
Dinner: ½ loaf of bread, ½ lb. mutton stew, beans or stewed fruit, potatoes, tea.

The jail was adequate for only four to five years. Because the law required separation of classes of prisoners, there was such a lack of space that the county was forced to build another jail at a cost of $40,000. The construction lot, 60 by 140 feet, was on Third Street just east of Hinton Avenue in Santa Rosa. It was built in 1891–92 with two tiers of cells. One cell was designated specifically for women. It didn't take long before the residents of this hoosegow lettered on the walls "God bless our Home" and "Eat, drink and be merry." The jail was noted as "one of the best and most substantial on the Pacific Coast"—that is, until May 1892, when a convicted murderer escaped. The statistics at the end of 1892, the first full year of the jail, showed that there were 500 prisoners, of whom 346 had committed misdemeanors. At the time, there were 13 homicides and attempted homicides, at a rate of 1 per 2,960 people.

One of those convicted of murder was George Bruggy. He escaped by sawing through the bars of the jail and was captured a few weeks later. After numerous reprieves on his death sentence, Bruggy escaped once again, this time never to be recaptured.

In 1893, Sonoma County was shaken by the largest earthquake in recorded history up to that time. There was some damage to county structures, but none to the new sheriff's office/jail. There were no physical injuries to the inmates. When repairs were made to fix minor damage in the jail, electricity was installed in the sheriff's office, and by 1904, the office even had a telephone installed.

Early in 1897, Sheriff Samuel Irwin Allen owned a couple of young bloodhounds called Sam and I (Eye), to be used as trackers. These whelps were the pioneers of our K-9 units. Deputy Ed Wilkinson began our

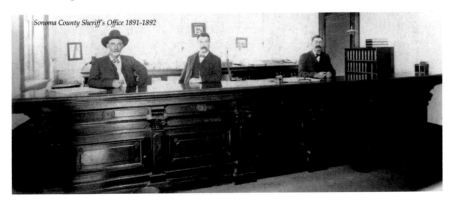

Sonoma County Sheriff's Office, 1891–92. *Courtesy of the Sonoma County Sheriff's Office.*

modern-day Deputy Dogs in the late 1960s with his Doberman pinscher named Cupid.

The quake of 1893 was a practice exercise for the North Bay, sheriff's office and the new jail. On April 18, the famous 1906 earthquake occurred. While all the brick buildings in Santa Rosa collapsed, including some wooden structures, the county jail of 1892 withstood the shake. The town counted over one hundred killed, but no major injuries were reported among the prisoners. The jail remained in use until it was torn down circa 1969, some seventy-six years later.

The county was focused for the next couple of years on regrouping its losses and rebuilding. With the courthouse totally disabled, a temporary structure was built across Hinton Street next to the Hall of Records. The sheriff's office suffered only minor damage. When the new courthouse was dedicated in 1911, the Hall of Records was included in the building. The sheriff's office took over the hall's old site off Hinton and Third Street adjoining the combination office/jail on Third Street. A new building was erected, and the jail was expanded into the front of the old sheriff's office, resulting in a reverse L-shaped structure when viewed from Third Street.

Crime and law enforcement continued its dance, each switching the lead to sounds of guns and wails of victims. In July 1910, the county and Northern California was shocked to learn about a triple murder above Cazadero at Lions Head Ranch. Twenty-seven-year-old Harry Yamaguchi, a ranch hand who worked for Enoch Kendall, committed the killings. On July 23, he killed Enoch, his wife and their son. The bodies were dismembered, and parts were found in the home stove and cast about the property. The governor of California offered a reward of $500, and the *San Francisco Examiner* added another $500. Yamaguchi fled to the East Bay and revealed the murders to an acquaintance. After being notified by the acquaintance, the police arrived, but Yamaguchi had gone and was never found.

Apparently, since the county was spending vast amounts of tax dollars due to the quake, a decision was made to have every office display the new courthouse on its letterhead. To assist the county spending, the sheriff was authorized, for the first time, to hire permanent deputies. Four deputies were sworn in by Sheriff J.K. Smith, at a wage of $1,025 per year. Sheriff Smith's salary was $2,000 per year.

On December 2, 1920, in San Francisco, three members of the notorious Howard Street Gang lured two young girls to a home, where they were "brutally assaulted." The three members—Terry Fitts, George Boyd and Charles Valento—promptly left the city, but their trail was traced by two San

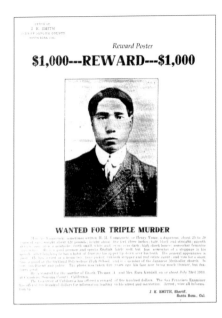

Reward Poster

$1,000---REWARD---$1,000

WANTED FOR TRIPLE MURDER

Wanted poster for Henry Yamaguchi, 1910. *Courtesy of Sonoma County Sheriff's Office.*

Francisco detectives to Santa Rosa. The detectives contacted Sheriff James Petray, and together they combed west Santa Rosa in search of the perpetrators. They were found at 28 West Seventh Street, and in a gun battle, Sheriff Petray and Detectives Jackson and Dorman were killed. In her in-depth history of Santa Rosa, Gaye LeBaron writes that in December 1920, a mob of people who were disguised and masked "overpowered" jail personnel and removed the three prisoners who were being held for the murders. The mob took the three prisoners to the Rural Cemetery on Franklin Avenue. An area fifty feet from the street was lit up by car headlights. The three bound prisoners were dragged beneath a locust tree and lynched. The leader of the vigilantes made everyone remain at the grisly scene until the three were dead. It was the next-to-last lynching in California.

During Prohibition, the main task of law enforcement was to suppress the making, shipping, dispersing and consuming of alcohol. The raiding of county residences or barns for the illegal product was almost a daily occurrence. From Sonoma to the sea, bottles and barrels were confiscated and the suspected parties arrested. A location four miles west of Santa Rosa had five stills producing 680 gallons a day "of the best moonshine obtainable in the county." The guilty suspects were generally sentenced to four to six months in jail, plus a fine.

The jail count for arrested persons in 1927 was 745. Liquor violations accounted for 104, while disturbing the peace was 115. The infractions occurred mostly at the summer resorts and dance halls. Most violators were handled by the justice courts in the outlying communities of the county without being brought to the county jail. Many communities even had their own places of incarceration; shabby wooden boxes passed as a suitable holding cell and were paid for by the respective townships through taxes.

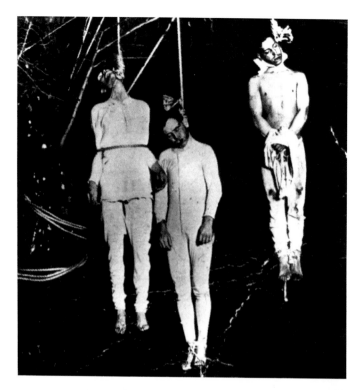

The 1920 lynching of Terry Fitts, George Boyd and Charles Valento. *Courtesy of Sonoma County Sheriff's Office.*

The Guerneville Jail, located along the north side of the railroad just east of downtown, circa early 1900s. *Courtesy of John C. Schubert Collection.*

In the late 1920s, Guerneville got a new jail. As reported in a newspaper article in February 1928:

> *Guerneville is to have a branch "office" of the county jail for the accommodation and incarceration of drunks, peace disturbers and other miscreants during the summer, when the population of the Russian river section is larger than that of the county's three chief cities combined.*
>
> *Through the efforts of Supervisor Willard Cole at the suggestion of Sheriff Douglass Bills, the county has acquired a huge steel tank from the phenol plant at Guerneville, now being dismantled. As large as a boxcar, which is its general shape, and of solid steel, the tank will be remodeled, equipped with sanitary conveniences and barred doors and windows, and divided into two or three cells. It will stand on a strip of land just outside the town, between Rio Nido county road and the railroad right of way.*
>
> *This plant will be of great convenience to county officers and special deputies in the river section. Under present conditions, sheriff's officers from Santa Rosa are called upon at all hours of the night during the resort season to go to Guerneville and bring arrested persons here, and later have to return them to the river town for hearing. Otherwise the special deputies bring them to the jail here, in which case it is necessary to bring them back to Guerneville for trial.*
>
> *Keeping the prisoners in a convenient local "county jail" will pay for the cost of the tank in a short time it is estimated.*
>
> *Guerneville at one time had a prison, a wooden structure, for the temporary incarceration of arrested persons. But the first man, who decided he did not want to remain locked up just kicked the side out of his cell and walked out, so the jail was abandoned. Monte Rio has a strong and sufficient branch county jail at present.*
>
> *At the height of the resort season, because of the great influx of a temporary population, many arrests were made in the river section. They are mostly for misdemeanor offenses, peace disturbance at dances being the most common offense.*

Thus, the first of three future and "permanent" satellite county jails came into being. Prior to the time, jails were of local jurisdiction, in city police departments and judicial townships. The future would see the construction of the Honor Farm/North County Detention Facility and the Sonoma Valley Substation. The holding cells at Guerneville and Sonoma are no longer used.

The "dry" Roaring Twenties gave way to an even more "dry" and "depressing" 1930s. Because of a lack of jobs, the labor unions were very active, not only in industry but also in agriculture. Many people at this time put union recruits in the same category as communists. The political atmosphere was tense and dangerous in 1935.

In 1935, a seventy-year-old rancher, Al Chamberlain, was a person trapped in the past. He had acres, horses and cattle and was a rancher in every sense of the word. He lived in the hills around St. Helena Road and couldn't (or wouldn't) master the mechanical things of the day, especially automobiles. Even in the 1930s, he rode to town on horseback and was teased and became the butt of jokes. However, the city had problems with him because of the smelly corral he had near the center of town and ordered him to close it down, with Chief of Police Charlie O'Neal signing and delivering the order. The old rancher was thrust headlong into the twentieth century and eventually took to the wheel. One day in June 1935, Chamberlain's problems with cars came to a head when he struck a pedestrian. O'Neal charged him with reckless driving, and he was sentenced to a month in jail and a $100 fine. Life and society had become too much for Chamberlain to deal with. He loaded up his guns and came to Santa Rosa. He walked into the police station and saw Chief of Police O'Neal. He shot the chief three times and left, heading across the parking lot to the sheriff's office, intending to shoot Sheriff Harry Patteson. Patteson heard the shots and went out unarmed. He saw the man with two guns. As they walked toward each other, Chamberlain asked him, "Are you Harry Patteson?" The sheriff said, "No" as they continued toward each other. Then Chamberlain recognized him, raised his gun and fired a shot, missing. Patteson hit Chamberlain with a body block, and they both went down. Patteson, with the aid of two citizens, captured the old man. Chief O'Neal died two days later from his injuries. Old man Chamberlain lived out the rest of his life in prison.

Two months later, Sheriff Patteson had his hands full with union organizers. There were marches by the organizations in the county and there were strikes by more than 500 crop pickers. Sheriff Patteson deputized in excess of 140 men. Later, his posse grew to 500 special deputies. He was ready if there was a riot out in the fields or packing plants. Additionally, during this turbulent time there were more than 200 vigilantes looking for Reds. Night-riding vigilantes rounded up some registered communists and took them to a warehouse down at the railroad tracks in Santa Rosa. There they made the captives kneel and kiss the flag. A couple refused and were promptly beaten, tarred and feathered, then thrown into a car. A parade

of cars went around and around the downtown courthouse, past the Santa Rosa Police Department and the sheriff's office, firing guns, honking and yelling. No deputy or police officer made an appearance at the sound of the disturbances that night. The two beaten men were taken out to the city limits by the nightriders and given twenty-four hours to get out of the county with their families.

Twenty-two people were charged with various crimes against the two men and the state. At the preliminary examination, among the defendants were two highway patrolmen, a member of the coroner's office, a future deputy sheriff and a future police officer. After the examination, ten defendants were discharged of the twenty-two charges. The remainder were found not guilty at trial.

Patteson's career was interrupted by the election of Andrew Wilkie in 1939. Wilkie's staff consisted of thirteen deputies. Among these were future sheriff's captain Bill Barnett; Bill's future boss, Sheriff John Ellis; and matron Grace Bixby, grandmother of television star Bill Bixby. By this year, the sheriff's office had a radio and dispatcher.

Wilkie's term was during the beginning of World War II. Being close to the Bay Area, and with two air bases in the county, the military men had to go somewhere to let loose. Many would visit the River Area on liberty. Big bands, bars and ladies of the night all prospered. Almost all visitors who came to the river resorts came from places where law enforcement officers wore uniforms. The sheriff's office had no requirement to wear a uniform, but those who worked and lived in the river resort area had to have them. When a plainclothes deputy would put the arm on some miscreant, a confrontation usually occurred. To make their job easier, Resident Deputies Tunis "Pete" Bever, "Tex" Nicholes and Bill Moore purchased their own outfits, which were basically tan, with some personal variation. The shirts they bought to wear didn't match. They were issued badges by the department, and as there was no sheriff's insignia in existence, their sleeves were void of patches.

Sheriff Patteson was reelected and continued in the prewar style, responding to calls, on-view violations and helping overcome family tragedies. Such a tragedy happened in November 1949 at Wohler Ranch. The screams of five-year-old Esther Silva and the repeating sound of a shotgun attracted a neighbor rancher who armed himself and ran to the scene. At a farm worker's cabin on the Wohler property, he found three bodies: those of Clyde Howard, twenty-three; his wife of one week, Louise; and Esther Silva's mother, Maria. A few minutes later, Tony Abaya was shot at his cabin at the Grace Ranch. Other armed neighbors came to the scenes

and promptly called the sheriff's office. The suspect, Polcerpacio "Henry" Pio, was captured on the outskirts of Santa Rosa by the police at College Avenue and Link Lane. Pio gave no resistance. His loaded shotgun was in the car. Sheriff's investigator Robert Dollar, with others, found fifteen gun shells at the first cabin and nine at the second. Pio admitted to shooting the four. He was sentenced to life with the possibility of parole.

The postwar era, from 1945 to 1960, was a boom time for the county, and the population grew with both residents and vacationers. Law enforcement was always doing catch-up with both the criminal element and casual violators. During the summers, the sheriff would hire summer deputies to work in the River Area and Sonoma Valley. Many were schoolteachers on summer breaks, while others were college students breaking into law enforcement. The Valley Substation would get three or four temporaries, and the River Substation would have as many as six or seven.

Even though there was radio dispatch for the deputies, the broadcast signal didn't reach into the outlying areas of the county. They were either

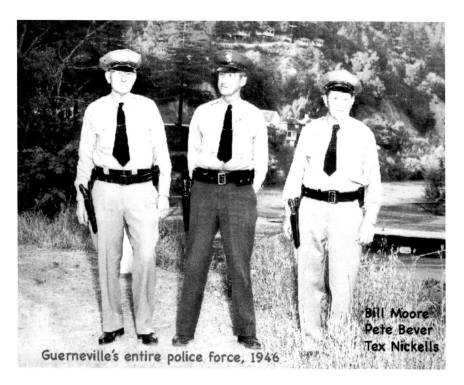

Group photo of Guerneville's police force in 1946. *From left to right*: Will Moore, Pete Bever and Tex Nicholls. *Courtesy of John C. Schubert Collection.*

too far away or intervening mountains and hills blocked the signal. To get a deputy to respond to a call out in the hinterlands, the dispatcher in Santa Rosa would land-wire the substation. A red light would turn on outside the station, and when a deputy saw the light, he would call Santa Rosa for his instructions. In the central county, there was no problem except when one patrolling deputy wished to talk to another. If one deputy wanted to, he had to request the dispatcher to connect him to a direct two-way communication, a switch, so the two deputies could talk to each other with dispatch listening in. After every transmission by dispatch, FCC dictum required them to state the sheriff's station call letters, "KMA 392."

The dispatcher's office in the main office was at the front door of the building alongside the main hallway. The sheriff's secretary, besides regular duties, handled the front counter during the day, while the dispatcher handled the swing and graveyard shifts. Though these last two shifts were the busy hours for deputies, the number of inquiring people assisted by the dispatcher was low because these were not regular business hours. There were four dispatchers to cover all shifts. The dispatch office was a single room ten by ten feet. There was a little room to the side with soundproofing, where the teletypes were located. Other dispatcher duties, besides logging phone and radio calls, included monitoring the teletype and occasionally "baby-sitting" a newly arrested person when the jail was too busy booking a large number of incoming arrestees.

Patrol cars during the early 1950s were, by today's standards, very basic. There was a white spotlight on the driver's side, and if the deputy had to go Code 2 or 3 (lights, no siren, non-emergency; and lights with siren, very emergent, respectively), he slipped a red lens with springs over the light. The siren was driven by an electric motor. When engaged, the electricity drawn from the car would slow down the car. The vehicles were unmarked and were mostly two-door sedans. They were without a divider between the front and back seats, as there is today for deputy protection. An early '50s car had a six-cylinder flat head engine, an example of law enforcement playing catch-up.

The county would experience mob violence in the second half of the twentieth century. The first occurred in March 1953, at Los Guilicos School for Girls. This was the official title of the California Youth Authority for the juvenile female detention facility. (This would eventually become the county's Juvenile Hall and the Regional Police Academy.) The inmate count at Los Guilicos was over 150. Led by a young teenager, a group of 20 escaped, breaking furniture, windows and anything valuable. After a night of chaos,

destruction and freedom, some 30 girls were injured. The sheriff's office, Santa Rosa Police, California Highway Patrol and Sonoma State Hospital Patrol Security force from Glen Ellen quelled the riot.

Election year 1958 saw John Ellis, chief of police in Sebastopol and former deputy, run for sheriff on the platform of having patrol cars marked and deputies in uniform. Very few police agencies in the state were without public identification. The platform proved to be a winner. However, it would be a year and a half before the promise appeared on the streets. The type of uniform, its material, shoulder patch design and patrol car markings took time to select.

In the mid-1960s, the new uniform would consist of forest green "Ike" jacket and pants with blue and yellow stripes around the cuffs of the jacket and down the legs of the pants. Shoulder patches were silver lettering on a blue field and Vallejo's Petaluma Adobe in the middle. The hat was Ellis's favorite: a Stetson 3X Beaver, Open Road, light gray in color. The necktie was blue, similar to Greyhound drivers or the Boy Scouts.

Under John Ellis's administration, some modern, contemporary ideas and facilities were implemented. The county had purchased a 470-acre parcel north of Santa Rosa in 1955. With the opening of the freeway in 1955 and suburban development of east Santa Rosa, the county was looking at more expansion of its legal offices. In 1962, plans were drawn up for the construction of a new courthouse, combining the probation department, courts, county clerk's office, sheriff's office and jail. The jail of 1892, the sheriff's office and the courthouse of 1910 were long outdated.

The first female deputies in uniform did not work full time but on a time-shared basis. They were Viola Maguire, Loretta "Mom" Derry, Ester Joliff and Dorothy Jarvis. They worked the jail, patrol and the courts.

It was also at this time that the racial line was crossed and then eliminated. The first African American hired by the sheriff's office, and probably the first in law enforcement in the county, was Jim Brown. He was hired around 1962–63. College educated, he was at first a jailer and then made sergeant. He eventually made lieutenant and was night watch commander. Lieutenant Brown retired in January 1985.

Prisoners in civilian clothes would no longer be marched across Hinton Avenue from jail to court every morning in a chain gang. It was a daily ritual for friends and many other people to line up on the sidewalks and watch the procession proceed to court. In 1965, the new Hall of Justice and jail was completed at a cost of $3,854,000. The new jail had a capacity of 214 males and 36 females and was occupied in January 1966. There were a total of 75

Deputy Loretta Derry *Deputy Viola Maguire* *Deputy Dorothy Jarvis* *Deputy Ester Joliff*

Above: Female deputies of the Sonoma County Sheriff's Office. *Courtesy of Sonoma County Sheriff's Office.*

Left: Lieutenant Jim Brown, Sonoma County sheriff's first deputy of color. *Courtesy of Sonoma County Sheriff's Office.*

sworn personnel, including all sheriff's administration, secretaries, clerks, radio dispatchers, jailers and deputies.

The new sheriff's office was expansive. The front lobby waiting area was fifteen feet by fifteen feet, and everybody in the patrol division from detective on up had an office. The jail had a sally port for patrol cars to drive in with in-custodies, which eliminated having to walk them from the car across the parking lot to the jail.

The jail was very modern, with electric sliding doors controlled at a main panel. An intercommunications system allowed jailer/deputies to keep better security over inmates, as well as themselves. The intercom even extended to the three court holding cells on the second floor in the Hall of Justice. Bailiffs could notify the jail when prisoners were ready to be picked up or ask for delivery of one. The intercoms fell into disuse with the advent of personal radios issued to the bailiffs. For the first time, prisoners were brought from jailer to the courts in a totally enclosed cement walkway across the top of the building. This pretty much eliminated the chance of an escape.

DEDICATION
of the
SONOMA COUNTY
HALL OF JUSTICE AND JAIL

JANUARY 15, 1966

COUNTY ADMINISTRATION CENTER

2555 MENDOCINO AVENUE, SANTA ROSA, CALIFORNIA

Left: Dedication flyer of the current Sonoma County Hall of Justice and Jail, circa 1966. *Courtesy of Sonoma County Sheriff's Office.*

Opposite: Composite image spanning three decades. Notice that the younger portraits include many more deputies and staff. *Top*: 1939 sheriff and staff: *back row*: Leo (cook), Allen Early (civil), Primo Rocco (bailiff), Bill Barnett (deputy and ID), Paul Noonan (jailer), Cedric Cutter (valley); *front row*: Grace Bixby (matron), Ted Lewis (undersheriff), Al Wilkie (sheriff), Stuart Rich (chief deputy) and John Ellis (deputy). *Center*: Sheriff John Ellis and staff in their first departmental approved uniforms, 1960. *Bottom*: Sheriff's staff on the steps of the sheriff's department at 600 Administration Drive, Santa Rosa, 1971. *Courtesy of the Sonoma County Sheriff's Office.*

It would be two or three years before all detainees would be in jail clothing while appearing in court. Until a person was sentenced, they would appear in their personal civilian garb. It was commonplace to have three or more prisoners sitting in court in plainclothes, with only one deputy/bailiff as guard. He would not have a weapon, radio or regular street equipment, with the exception of handcuffs. Since there were no phones in the courts, many times it was necessary to leave the court unguarded while in session. Surprisingly, attempts to escape were next to nil.

In 1970, Don Striepeke was elected sheriff. The change in leadership was a change from old-style enforcement to modern law enforcement. More expansive communication facilities, more extensive training, tactical scenarios with special squads, special enforcement units and many others were implemented. Sheriff Ellis opened the door for the new sheriff (Don Striepeke) to usher it in.

During the late '60s and early '70s, there was social unrest in Sonoma County. The hippie culture was underway, with its related drug use, the Vietnam War and its antiwar demonstrations; the county was a busy place to work.

A pivotal year for the jail was 1972. No longer would deputies be assigned as jailers. The first correctional officers came from state academies trained specifically in how to handle prisoners while in custody.

The biggest event for the office was a jail riot on March 7, 1972. The disturbance started around 5:30 p.m., when an unidentified inmate violently tossed his food tray onto the floor. Within minutes, 145 inmates were

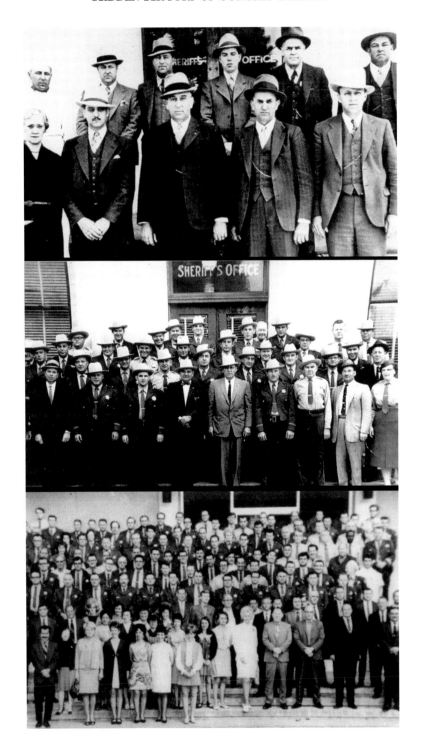

Left: Interior of the Sonoma County Jail after the 1972 riot. *Right:* Exterior view of the jail. *Courtesy of Sonoma County Sheriff's Office.*

rampaging within the jail walls. Approximately one thousand small panes of glass were broken out by inmates using long spear-like metal pieces from the fluorescent light fixtures. Similarly large windows throughout the second floor were also broken out. Inmates smashed television sets; broke pipes; tore electrical fixtures off the walls; set mattresses, linens and clothing on fire; and plugged sinks, flooding large areas of the second floor. The inmates tore a heavy twenty-foot metal shelf, weighing about three hundred pounds, from a washroom wall and used it as a battering ram to break out of their cells. They worked their way outside into the recreation yard, apparently in hopes of escaping over the jail roof two stories above.

City law enforcement agencies volunteered to handle all calls for assistance within the county while the sheriff's units concentrated on the situation in the jail. Officers from the California Highway Patrol surrounded the building on the ground level, while other officers were posted at strategic points on the roof. Members of the sheriff's office and Santa Rosa Police Departments assembled on the second floor, where they dispensed two pepper foggers, which disabled the rioters and forced them to retreat. The officers herded the inmates back down to the first floor, where they were stripped of their clothing, searched and placed in-mass in several large holding cells. Fortunately, no officers were hurt, and 3 inmates received only minor injuries. The damage was so extensive that the courts deemed the facility uninhabitable and ordered the transfer of 101 inmates to San Quentin Prison while repairs were made. The total loss was estimated around $75,000.

Once the jail was repaired, Sheriff Striepeke ordered deputies back to work in the jail to assist correctional officers in curtailing future violence.

Correctional officers performed all the booking processes, while the deputies acted as movement officers and were in charge of all the hands-on processes with the inmates. Sometime after, deputies were removed from the jail, and full charge was once again given to correctional staff.

During the Ellis and Striepeke years, many ideas and tactics were tried to assist the individual deputy and the sheriff's office. These would entail the use of helicopters, dogs, underwater teams, four-wheel-drive patrol vehicles and individual radio communication systems. Changes within the sheriff's office were happening at a more rapid pace. With the continued crime-fighting innovations in law enforcement and improved detention services, the Sonoma County Sheriff's Department continued to grow and advance.

Chapter 7

HANGING AT GRAVEL SLOUGH

S onoma County has had violent chapters in its history. Some have been
due to nature—floods, earthquakes, etc. Others were due to people—
mass murders, communist witch hunts, stagecoach gangs. Although this was
not the first event in which a part of Sonoma County's population turned
against the law, the lynching of three men in 1920 is among those most
vividly remembered.

Charles Henley was a fifty-seven-year-old Missourian. He was a large man
and married. For ten to twelve years, the Henleys had lived on Brooks Creek,
located about one and a half miles southeast of Frank Bedwell's property.
One of their neighbors was a forty-five-year-old bachelor, James Rowland,
a native of Ireland. His property, split by Bedwell Creek (now known as
Bidwell Creek in east Healdsburg), was about a half mile north of Henley's.
This area is about eight miles northeast of Windsor back in the rolling hills.

There had been some trouble with Henley's hogs running loose in the
canyons and hills on various neighbors' properties. It was a warm spring day,
May 9, 1876, when word was sent to Henley that his hogs were corralled
over on Rowland's ranch. Charles told his wife he was going over there to
see. She thought there was going to be trouble; he had left with a shotgun.

Henley got to Rowland's that mid-afternoon, but no one was in sight.
Charles looked around and found his hogs in the corral. As he was about
to open the gate to drive them out, Rowland came running from around
the barn, yelling, "You damn son of a bitch! I have just got you where I
wanted you!"

The scene of the crime: the lands of one-time neighbors Charles Henley, James Rowland and Frank Bedwell are shown here in the *Historical Atlas of Sonoma County*, 1877. Rowland's death was quickly acknowledged by the mapmakers who identified his property as the "Estate of Rowland." *Courtesy of John C. Schubert Collection.*

"Stop where you are, Jim," barked Henley.

Rowland ran into the corral toward Henley. At ten feet, Henley jerked up the shotgun and fired. Rowland was flung backward to the ground, the left side of his head and body hit by the blast. He was dead. Henley bolted from the corral.

It was about 5:30 p.m. when Charles got home, empty-handed. His wife asked him, "Have you found the hogs?"

"Yes," he answered, "I found them on the hill. I ran after them, but I couldn't catch them."

About eleven o'clock that night, Charles saddled up and rode over to Robert Greening's ranch. The lamps were burning in the house as Henley rode up. Greening and hired hand Bill Goodman were getting ready to bunk down. Greening came out on the front porch in his stocking feet. "Hello, Charles." Henley swung down from his saddle, saying, "Hello, Robert," and shook hands with him. Charles asked, "Are you a friend of mine?"

"Yes."

"Will you stick by me?"

"Yes," answered Greening. "What's the matter?"

"I've got into trouble with Jim Rowland. I shot him. What should I do? I want your advice."

"I hate to give any advice at all," Robert said, "but if I was in your place I would go and give myself up."

"I'm on my way to give myself up," Henley answered.

"Why don't you go to Windsor to surrender?" asked Robert.

"I won't go there. They are all Odd Fellows. Don't tell Bill Goodman, as he's an Odd Fellow, too."

Henley mounted up and rode off into the night, taking Greening's advice. He surrendered himself to the authorities in the dark morn at Windsor.

Meanwhile, back at Rowland's ranch, hired hand Joe Dennigan got home a little after midnight and went to bed. He got up about 5:00 a.m. to feed the chickens and discovered Rowland's body in the corral with his two dogs lying on opposite sides of their master. The chickens and hogs had mutilated Rowland's left side almost beyond recognition. Dennigan hurried over to the neighboring ranch of John Hopper and told him what he had found. They both returned to the grisly scene. Hopper later stated, "Found no weppins or could I see any sine of arms about the corral or the boddy [sic]."

Later that morning, May 10, Coroner Kelly Tighe held an inquest in the corral over the body of James Rowland. Twelve men—most local ranchers, like Frank Bedwell, Thomas Brooks and Henry Mardon—were impaneled to hear and see evidence. Testimony was taken from six witnesses. The coroner's panel found "that the said James Rowland came to his death by a Gunshot wound supposed to be inflicted from a gun discharged by the hand of Charles Henley—and find that said Henley is guilty of Murder."

Unknown to Henley, Goodman had overheard part of the conversation between Henley and Greening. Later that afternoon, members of the Windsor Odd Fellows Lodge came up to Rowland's ranch and claimed the body of their brother. After observing the ceremonies dictated by that lodge, James Rowland was buried in Oak Mound Cemetery, Healdsburg. His fraternal friends wore their badge of mourning for thirty days. On May 25, the Odd Fellows made a tribute of respect to Rowland and had it printed in several newspapers.

On May 20, some eleven days after the killing, a preliminary examination was called before Justice James H. McGee in Santa Rosa. The courtroom was packed with spectators to hear the case. The people were represented by G.A. Johnson and Judge James B. Southard, the defense by Major John

The Odd Fellows' published memoriam to Rowland, as it appeared in the *Santa Rosa Democrat* in May 1876. *Courtesy of John C. Schubert Collection.*

Brown and John T. Cannon. When Justice McGee asked if counsel was ready, Major Brown rose and stated the defense would waive examination and let the defendant, Henley, remain in custody until a decision was made by the grand jury. Henley was taken by Jailer Sylvester H. Wilson back to his cell adjoining the courthouse, where he languished for another twenty days.

It was near midnight on June 9. Approximately fifty to seventy-five men in wagons, buggies and on horseback rode to Santa Rosa. When they reached town, the nightriders broke up into smaller groups. One band drifted up toward the courthouse in a wagon. Along the way, some men dropped off. They were noticed coming up C Street (today's Santa Rosa Avenue) on foot by the night watchman, Robert Dyer, as he was putting out the lights around the plaza (Courthouse Square). They crossed the plaza, went up Mendocino Avenue, going past the courthouse and went through the rear gate behind it. Dyer quietly followed them. They seemed to have gone into the public privy, so he returned to his chore of putting out the other lights. When he finished, he went back up the east side of the avenue and stopped opposite the back gate.

During this time, someone, unknown to Dyer, cut the rope to the fire alarm bell in the small firehouse next to the county building. The four men came out the gate and stepped over toward Dyer. When they cleared the shadow of the courthouse, he saw they were masked and armed, one with a shotgun. Dyer asked, "What's all this mean?" One of the masked men put a finger to his lips, saying, "Keep quiet. There are 150 of us, well-armed, and we have come to take a certain man out of jail." He told Dyer they would tear down the jail to get their man and it would be to his advantage to remain silent.

The Sonoma County Courthouse (*far right*) as it was in 1875. This view is of the northwest corner of today's Courthouse Square and shows (*from left to right*) an office building, the Santa Rosa firehouse, the county jail (with small dome), the brick cell block and the courthouse. *Courtesy of John C. Schubert Collection.*

They marched Dyer over to the house of Deputy Sheriff and Jailer Wilson on Fifth Street. It was now about 12:30 a.m. At the same time, Santa Rosa policeman Fuller was on the south side of town when he saw the wagon with the men go by toward the plaza and Dyer. Soon after, he met a masked man hurriedly coming down the dirt street. Fuller drew his pistol and ordered him to halt. The masked man quickly drew his gun "and arrested the policeman." For the next hour, Fuller was held captive.

In the meantime, Jailer Wilson and his family were home asleep. About 12:45 a.m., someone knocked on their front door, waking Wilson. When he opened the door, a crowd of armed masked men rushed in, grabbing him.

Wilson's wife screamed when she saw them. They told her to keep quiet and no one would get hurt, neither she nor her daughter.

The masked men quickly told the jailer they did not mean any harm to him but they wanted Henley at all hazards and they would have him unlock the jail. Four or five took him to his room so he could get dressed. Then, leaving eight or ten men to guard his wife and daughter, they walked Wilson out of his house. Just then Dyer, under guard of the other four, arrived at Wilson's front yard full of masked men. The mob with their two captives went down the dark streets to the courthouse. When they got to the sheriff's office next to it, the jailer was forced to unlock the office. It was now about 1:00 a.m.

Wilson lit the gas lamps inside and was ordered to unlock the jail. He did as he was told. He opened the first two doors, the men following him into the cellblock with lit candles.

"Which cell is Henley in?"

Wilson pointed. Two men pressed their guns at his head. "Open it!"

Quickly opened, the men looked into the cell by the light of the candles. Henley was quietly sleeping. Four men grabbed him. He woke: "Oh lord, boys, spare my life!"

Those were his last words.

The four quickly gagged and bound him. The hall was lined with the black guard as they carried him out feet first. It was the last Wilson saw of Henley. Wilson locked the jail and was brought back into the sheriff's office, where he and Dyer were ordered to sit down. For the next thirty minutes, the ten guards talked of locking the two up. Then it was decided to take them out into the country. "Keep quiet and nothing ill will come to you two."

A wagon was driven up to the courthouse, and the two, plus the guards, climbed in and were driven to Wilson's home. The masked guards there left Wilson's family and rejoined the mob. From Wilson's, the criminal crowd took their "prisoners" down Fifth Street, turned south along the railroad tracks near the depot and then crossed the Third Street bridge over Santa Rosa Creek. When wagons and riders reached the timbered flat southwest of town (near today's Roseland District), they put Wilson and Dyer out in the road.

At the same time, several wagons, buggies and horsemen rode up. They talked among themselves, calling one another by number, not using names at any time. They passed a whiskey bottle around and offered it to the two captives. Wilson and Dyer refused. The nightriders then rode off into the

night toward Sebastopol. The jailer and night watchman started walking back to Santa Rosa. It was now about 1:30 a.m.

Back in town, the released Policeman Fuller woke the city marshal, Jim M. White, and told him what had happened. White and Fuller went to the jail and were met by Wilson and Dyer.

"I think they haven't taken Henley very far," White said. "I'm going down to look for him."

The marshal, joined by Wilson, Dyer, Fuller and citizen Frank Carrillo, retraced the route back to the wooded flat. About 150 yards beyond where Wilson and Dyer were released, they reached Gravel Slough. Hanging from a tree along its bank about seven feet from the ground was Henley, with a rope over a limb and tied to a root "so high that the swine could not feed upon him." Henley was lynched.

The marshal let him down, and the four brought Henley back to town. By now, the purple of dawn was beginning to show. The news traveled rapidly through the county seat and countryside. A large crowd gathered about the courthouse that morn. One writer to the *Santa Rosa Daily Democrat* stated:

> *I soon learned the cause of the excitement and after hearing the horrors of the night detailed by those who participated and witnessed them, I was horrified and disgusted to witness the levity with which the subject was treated by some of the officials, and especially those who had failed to perform their sworn duty in protecting the peace of the city. I am told that even over the dead body of the victim of the mob, jokes were freely cracked.*

Repercussions directed at both the unknown lynchers and local police agents were simultaneously issued by the public at large:

> *For the first time in its history Santa Rosa has been outrageously disgraced by the violence of a mob....The act last night was a dastardly outrage on the law and common decency. There can be no excuse sufficient for the overturning and bringing into contempt of the majesty of the law which protects life and property of every citizen.*
>
> *No effort should be spared to bring the perpetrators of this crime to justice. There is no shadow of excuse for such a proceeding. Organized crime is much worse than individual violation of the law.*

A map of downtown Santa Rosa, taken from the Historical Atlas of *Sonoma County*, 1877. The route taken by the lynch mob with Henley is drawn in with a bold line. *Courtesy of John C. Schubert Collection.*

The San Francisco papers—*Chronicle, Alta, Post*—printed long editorial columns condemning the "diabolical outrage" and contending that "the era of Vigilance Committee has passed in the state." It should not rise again.

The other outcry was about the conduct of individual and collective nonaction of the law enforcement personnel. Here are five samples from a hundred:

> *The officers were led like lambs dumb to the slaughter.... The city pays half as much for public schools, and if last night's work is a sample of their use, we think they had better abolish all except the Marshal and one deputy.*

> *When a man voluntarily assumes the responsibilities of a policeman it is understood that he takes some risk....I presume that the City Council will deal with the inefficient members of the police department.*

> *Officer Fuller surrendered to a single man...a more pitiful exhibition of incapacity.*

> *Under these circumstances every derelict officer ought to be properly dismissed.*

> *It has been suggested that the fellow who captured an officer in this city be employed by the City Council as a policeman.*

121

A third complaint heard and read was the story that the mob was composed of members of the Odd Fellows, who, if not actually engaged in the lynching, instigated the movement. The *Santa Rosa Daily Democrat* wrote, "Such reports are unfounded, infamous and slanderous."

And so it went—the public incensed at the soiling of the city's and county's reputation and enraged at the inaction of the police, most directed at Fuller. As with most horrific events, some people on the periphery were seriously affected. Charles Hall was in the neighboring cell to Henley that infamous night. After that, Hall acted very strangely. He thought there was a plot to take his life and was in constant horror. Many came to fear that he had become demented.

While all this was going on, the various levels of local government and their agencies made attempts to discover the identity of any member of the mob and made official reports and findings. The first came from the coroner's jury the day Henley was hanged. It covered no new facts that weren't already known. Sheriff Joseph Wright wrote the weekly *Sonoma Democrat* that he had laid plans for the discovery and capture of the outlaws and when he thought it would do any good to offer a reward, he would do it. For approximately five days, nothing was noted in the county's periodicals. Then Sheriff Wright, apparently due to a lack of information and clues, made his offer of a $500 reward.

A week later, on June 24, the *Sonoma Democrat* asked the board of supervisors and California governor William Irwin "to increase the bounty" for any person connected with the mob. Two days after the paper's request and ten days following the sheriff's notice, the state posted its reward of $1,000. Action and reaction dragged on into July. The Honorable John G. Pressley, judge of the district court (equivalent to Superior Court), instructed the grand jury as such:

REWARD!

WHEREAS, ON THE 10TH DAY OF JUNE, 1876, one Charles W. Henley was taken from the County Jail of Sonoma County by a mob of masked men, and by them ruthlessly hanged:
Now, therefore, by virtue of the authority in me vested, I do offer a reward of

$1,000.00

For the apprehension and conviction of one or more of the guilty parties engaged in the transaction.
In witness whereof, I have hereto set my hand and caused the Great Seal of the State to be affixed, this, the 26th day of June. A. D. 1876.
[SEAL.] WILLIAM IRWIN, Governor.
ATTEST: THOMAS BECK,
je27-dw2m Secretary of State.

$500 REWARD!

IN THE ROOMS OF THE HONORABLE Board of Supervisors of Sonoma County.
An outrage having been perpetrated on the people of Sonoma county by a body of masked men in forcibly taking one Charles W. Henley from the county jail of said county and hanging him, now, by virtue of the power in them vested, it is hereby ordered by this Board of Supervisors, that a

Reward of $500

Be paid for the arrest and conviction of any person or persons engaged in said transaction.
W. K. ROGERS, Chairman.
Attest: JNO. T. FORTSON, Clerk,
By VIRGIL E. FORTSON, Deputy Clerk.
jy14-dwlm

$500 REWARD!

I WILL PAY THE SUM OF FIVE HUN- DRED DOLLARS in Gold Coin, for the arrest and conviction of the persons who forcibly entered the Sonoma county Jail on Friday night, June 9, 1876, and took therefrom and hung Charles W. Henley. Or, I will pay said amount for the arrest and conviction of any one of said persons, This reward will be good during my administration.
JOS. WRIGHT,
Sheriff of Sonoma county, Cal.
Santa Rosa, June 16, 1876. je17-dwtf

Newspaper notices of rewards for vigilantes' arrest from the Sonoma County Sheriff's Office, published June 16, 1876. *Courtesy of John C. Schubert Collection.*

It is my duty, gentlemen of the jury, to direct you to leave no means in your power untried to ascertain who have thus violated the law. You have a right to subpoena any person as a witness whose testimony may in your judgment be likely to throw any light on the subject, and the power of the county is at your disposal to compel the attendance of such persons.

You should also inquire into the conduct of the officers who had charge of this prisoner, and if they have been derelict in their duties you should say so; but if they have done all that efficient, prudent officers could do to prevent this unfortunate occurrence, and to arrest and bring to justice the offenders, they should be exonerated from all censure or blame.

On July 8, the grand jury made its report. The most important of its findings is as follows:

In respect to Jailer Sylvester Wilson we find that by an artifice he was overcome by an armed force, when he had no arms or other adequate means of resistance and we therefore exonerate him from any blame in the matter.

In respect to the conduct of the two policemen Dyer and Fuller we cannot say as much; in our opinion they did not exhibit upon that occasion in question those qualities that should mark the character of efficient peace officers.

In summation, there was nothing new, only more heaping of blame on Fuller and Dyer and more exoneration of Wilson. On July 11, after a month had passed, the city council of Santa Rosa finally made an official motion and removed the night police, Fuller and Dyer. Two days later, the board of supervisors offered a $500 reward. The total of the rewards was now $2,000—approximately two to three years' wages for the average worker of those times. The pursuit of the nightriders continued on. Nothing occurred; nothing was uncovered. Nothing.

The rewards ran in the newspapers until late August. The sheriff and board of supervisors withdrew their notices on August 22, and the state stopped its notice on August 30. No information has been found regarding Henley's widow. No mention was ever made of her during the whole tragic event, from Rowland's shooting through the court appearance to the withdrawal of the rewards. The whereabouts of Henley's earthly remains are also unknown.

EPILOGUE

Many times, a writer has completed a history as far as facts and evidence permit, but it is not the whole story. There are also facts that are asides to the central script.

James Rowland was considered fairly successful as a rancher. His estate was appraised for the county by neighbors Frank Bedwell, Henry Mardon and L.D. Latimer. It was valued at $12,714. Ironically, one of the counsel for his estate during probate was a man named Henley (no relation to Charles). Having searched through all historical sources known, I could not recover the name of Henley's wife, where Henley was buried or what happened to his estate. The last thing known of Henley was that he was brought back to Santa Rosa.

Rowland's death was on May 9. A peculiarity arises in that the lynchers went on their evil rounds on June 9, exactly one month later. Planned?

Who were the perpetrators and executors? Specific names allied with the numerous false imprisonments are unknown. But was there an organization coordinating and executing the plans that night? Obviously, yes.

Chapter 8

BLUE LIGHTS AND RED FACES

Santa Rosa's Red-Light District

Pimps, madams, johns, brothels—prostitution. Often talked about, seldom written of, especially in a community's own history. "Things like that" occurred elsewhere—big cities, near camps (military, work, clubs) and in other countries—not here. But Sonoma County's past is not immune from the world's oldest profession; Guerneville had its "cribs," Petaluma had its "Green House," Santa Rosa had its "Tenderloin."

The story of Santa Rosa's red-light district begins during the Gay Nineties. Located just south of Chinatown, the district, as identified by citizens and city, encompassed the area of First Street from Main (today's Santa Rosa Avenue) to E Street (a distance of two blocks) and D Street between First and Second Streets. Most adults (and some juveniles) knew of the district, including the local constabulary; however, little was done to suppress the bawdy business or declare it a public nuisance.

At the turn of the century, there were five or more known brothels. Many were owned by local capitalist and developer Con Shea: #1, #5 (run by Mabel Elliot) and #8 (operated by Sadie McLean) on D Street. On First Street, other owners were Mrs. Lowell at 710 and Mrs. Lowery at 718 (also known as the Chicken Coop). Later in 1903, Daniel Behmer built a two-story house at 720 next to Santa Rosa Mill, specifically as a "sporting house." The first madam in Behmer's was Mary Melville from Sacramento. She lasted about a year before she was run out of town.

The houses themselves, in most instances, had small rooms in which the "johns" partook of the services offered; due to their small size, these rooms were often called cribs. But these houses of ill fame offered more

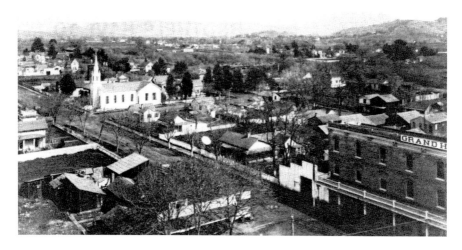

Downtown Santa Rosa, 1895. The Methodist Episcopal Church at the upper left stood on the southeast corner of D and Third Streets. Third continues west past the Grand Hotel at the lower right. The picture was taken from the top of the old courthouse. *Courtesy Don Silverek Collection.*

than just companionship and sexual favors; the Chicken Coop offered grooming services, and all brothels were permitted by the city to serve liquor (after purchasing a license for fifteen dollars per month), even though these "businesses" operated neither as restaurants nor saloons.

As with any business, there were expenses. The Santa Rosa sporting girls paid the madam five dollars per month plus fifty cents if a john stayed with them an hour or a night. This fifty cents was called "room rent" and was usually paid by the customer.

Men (and sometimes accompanied women) of all walks of life from Santa Rosa and the surrounding area came to the Tenderloin. Varieties of people, from the working stiff to the pillars of the town's social circles, business establishments and government, visited the brothel-lined boulevard. Because of the types of customers that would frequent these houses, the daylight hours were slow for this type of commerce. The women would stand on the front porches, scantily clad in the uniform of thin, loose-fitting kimonos that hung straight from their shoulders, open, and would call out to the males traversing the street. Age made little difference. Some who were convinced to join them were boys as young as fourteen.

Men who made deliveries to the bordellos were grudgingly allowed by the working girls to continue on their routes but only after they were physically restrained so the working women could taunt, flaunt and tease them to do a little business, mostly to no avail.

However, in late summer and early fall, business was fast and furious. These were the times when the horse races were running at the fairgrounds. Often when many men were waiting at the bawdyhouses, they would automatically step across First Street and form lines along the fences opposite the brothels. As many as fifty would wait just to get into Behmer's to "dis-sport themselves." When Sadie McLean leased Behmer's, she, with two other belles, could handle twenty-five patrons per hour.

Most of the girls working in the cribs came from the Bay Area. McLean had been working Santa Rosa for quite a number of years on First Street before she leased Behmer's. From San Francisco came Marion Watson, Ethel Dale and Virginia Watson. From Vallejo there were Sadie Ward and Gladys Fhriel, and Chico's Opal Browning came to work with Sadie. Santa Rosa also produced a few sporting girls: Bernice Melvin, Peggy Cushing and Daisy Hibbard, also known as "Birdie."

But all was not well with the Tenderloin. It ran into problems in the summer of 1907. Across First Street, opposite McLean's and Lowery's

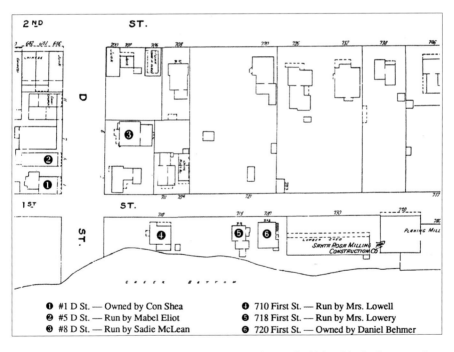

The sporting houses of downtown Santa Rosa were clustered within a block of one another, as shown in this reproduction of a Sanborn Fire Insurance Map (circa 1900). The key at the bottom has been added to identify the whorehouses. Some of these same buildings are visible in the upper right portion of the previous photo of downtown Santa Rosa. *Courtesy of John C. Schubert Collection.*

Chicken Coop, was the back fence to a Miss Lou Farmer's property, which had been in her family since 1855. Farmer was a churchgoing woman and didn't particularly condone the conduct and business of the employees and patrons along the back avenue. The men would get boisterous at any hour of the night, being lubricated with liquor before and after visiting the brothels. Loud cursing was common. The working women and patrons could often be seen in various stages of undress in front of windows by people in the street and by Farmer from her residence. Farmer sued Behmer in the county's court, claiming a loss of past and potential income, and also charged the bordello as a public nuisance and, as such, caused a depreciation of value to her property.

But there was a problem with the nuisance charge: the City of Santa Rosa had licensed the house to operate! The city passed Resolution #2 on May 11, 1907, in which it specifically defined the boundary of the Red Legal district, requiring establishments had to be licensed and outlining what provisions had to be maintained to keep said license. These provisions were (roughly summarized):

1. Pay a fee of forty-five dollars per quarter, collected by the chief of police.
2. Owner/lessee to keep a register of each guest boarding there, including arrivals and departures (not visitors).
3. Each guest was to be inspected by a doctor, and if a contagious disease was found, the guest had to vacate the premises.
4. Doctor was to give a certificate to each guest inspected.
5. Doctor was to review the guest register every two weeks.
6. Houses were to be kept in a clean, sanitary manner and in a quiet and orderly fashion.
7. Owners/lessees could dispense liquor under protections of the license without a specific dispensing permit.

An accounting of these provisions appeared in an April 18, 1907 edition of the *Santa Rosa Press Democrat*, after the Santa Rosa City Council first adopted a resolution governing the operation of brothels in the city:

> *The City Council had passed a resolution compelling the proprietors of the houses in the tenderloin district who furnish liquors to the frequenters of their resorts to pay a license of forty-five dollars per quarter.*

The payment of this license will do away with the much criticized practice in vogue here for many years, of arresting the women proprietors of the houses each month and fining them for misdemeanor, to-wit, selling liquor without a license.

The resolution also provides for the maintenance of better sanitary regulations in the tenderloin, medical examinations, etc. It likewise provides that a register shall be kept at each house of the guests frequenting the place, such register to be open at all times for inspection by the police.

Prior to adopting the resolution the Council went into executive session to discuss the matter, whereupon, as is the usual custom, the newspaper men and spectators present, took their departure. Later the Council temporarily convened in regular session and passed the resolution as above outlined. The resolution was adopted by unanimous vote of the Council, all members being present with the exception of Councilman Reynolds.

Though prostitution was illegal under the state penal code, even during those times, no criminal charges were ever issued. But Farmer's civil suit finally brought what was public knowledge into focus in the courts. The end result was that the judge declared that the city, contrary to state law, had tried to legalize the district and was therefore acting outside the law. He further declared that Behmer's house (leased by McLean) was built specifically as a house of ill fame and was therefore responsible for Farmer's financial loss. The judge declared Farmer "won" her suit. However, even though this case attracted the attention of the town (especially filling the courtroom during the taking of evidence), very little was done to suppress prostitution in Santa Rosa. After the excitement of the civil trial passed, life returned to "normal." Eventually, the bordellos closed, and the general area for this business gradually moved during the 1920s to the south neighborhoods of Santa Rosa Avenue.

Chapter 9

ALL ABOARD!

Last Ride on the Rails

Cazadero, 1933, and Duncans' Mills, 1935

There are important dates in everyone's life—birthday, graduation, wedding—that are never forgotten. The same thought can be applied to a town's "biography"—when its post office was established, the first day its school opened, the first train into town and the last to leave. These were momentous occasions, for trains were the lifeline to the outside world. However, as society developed, the railroad outlived its usefulness. Advents such as local transportation—autos, trucks, buses—and paved roads usurped the railroad's top position throughout the communities. No longer did people have to rely solely on the train.

Other factors that affected ridership include the reverberating effects of the Great Depression. With everyone watching their expenses, people were sharing rides, and riders would help pay for gas. For local travel, it didn't make sense to pay the cost of train fare when you could simply pay your neighbor the cost of fueling his car. The cost of traveling via car was cheaper than trains. These trending economic habits cut deeply into the railroad's revenue. Even if the company lowered fares and tariffs, it was not sufficient to save it from its inevitable demise. A third factor was the small rural population served by the railroad running through the countryside, usually parallel to a road.

Last train leaving Cazadero, July 31, 1933. Note the gravestone in the middle. *Courtesy Northwestern Pacific Railroad Historical Society, Fred Stindt Collection.*

This was repeated with the operations of the Northwestern Pacific Railroad (NWPRR). In 1876, the railroad, then known as the North Pacific Coast Railroad, rolled from Point Reyes Station via Tomales and Occidental and into Russian River Station (now the town of Monte Rio). It then traveled on to Duncans' Mills.

On April 4, 1886, the first official train from Duncans' Mills to Ingram's (today known as Cazadero) was inaugurated. A San Francisco newspaper, the *Daily Alta California*, recorded the story in its April 6 edition. It had a reporter invited by general manager John W. Coleman for the trip from the city to Ingram's. At Duncans', the party left Coleman's "palace car,"

taking an open flat car provided with improvised seats. [We] were soon whirling over the new extension, to Ingram's, seven miles distant, through a primitive forest whose shadows were too deep to allow a rift of sunlight to pass through them. It was a romantic ride, however, for the road is flanked at intervals on either side by Austin Creek, a stream as bright as a mirror, and broken into innumerable cascades, and pools where the salmon and trout delight to disport themselves. Here and there a fisherman was observed whose happy face indicated that his luck had been good and that his basket was well filled with gamey beauties of the brook. Plunging out of the redwood canopy after an hour's exhilerating ride, the train stops abruptly in

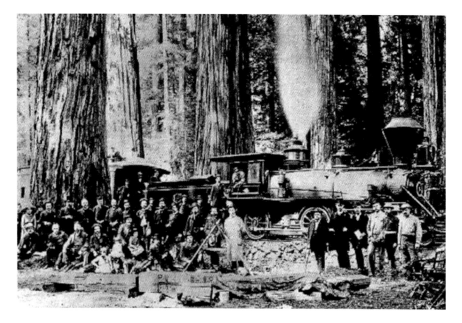

On April 4, official train service began; however, the first regular service passenger train entered Ingram's on April 11. *Courtesy of Henrietta Ingram Clement Collection, Lynn Jackson.*

> *an opening, and a little walk brings you suddenly to a commodious hotel, surrounded with broad porches from which a panoramic picture of stream and valley, meadow and mountain beauty is obtained. This is Ingrams'.*

Fast-forward fifty-two years, to 1928. The owners of the railroad, now the NWPRR, were in need of commerce, passenger and freight from Point Reyes Station to Monte Rio. It was not forthcoming. The company applied for and was granted a petition for abandonment by the Interstate Commerce Commission (ICC).

Fast-forward again to 1932. The Depression had now been inflicted on the country for three years, and the NWPRR was suffering its effects like everyone else. After forty-seven years of service to Cazadero, the company petitioned the ICC again on November 28, 1932, to abandon its line of seven miles from Duncans' Mills to Cazadero. The commission wrote in its report that the Cazadero branch of 7.2 miles

> *traverses a sparsely settled mountainous region. No industries are served and there is little agricultural development. The estimated number of inhabitants of the tributary territory is 385. [Shipping] decreased from*

132

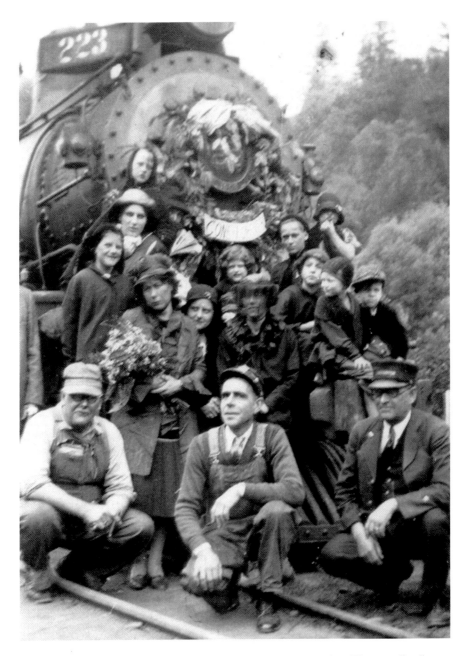

Train 223, just minutes from pulling out of Cazadero for the last time. The crew (*kneeling, left to right*): fireman, brakeman, conductor [unknown]. Faces in the crowd: Martha Bohan holding flowers; behind her right shoulder, Joan Peterson; behind Joan, Fran Bohan; behind brakeman's right shoulder, Ruth Peterson; behind his left shoulder in veil, Kitty M.; behind conductor's hat, Jim; far upper right in black hat, Betty; in middle below white sign, Peg. *Courtesy of the Russian River Historical Society.*

1,569 tons in 1927 to 694 tons in 1931. The first 10 months of 1932, however, the volume increased to 2,612 tons, due to shipments of material used in construction of highways.

The number of passengers decreased from 6,671 in 1927 to 4,178 in 1931.

Gross revenues accruing to applicant's system from operation of the Cazadero [line] decreased from $16,254 in 1927 to $7,019 in 1931.

To be sure, there were several witnesses who gave testimony in objection to the petition. The Boy Scouts of San Francisco said it would work a hardship on the four hundred to seven hundred boys who depended on this transportation once a year to Camp Royaneh at Watson Station. But six months later, on May 22, 1933, the commission granted the request.

The Northwestern Pacific notified the local citizens that its last train out of Cazadero would be on July 31. This gave the people two months to decide what to do to commemerate this sad but historic event: "NOTICE TO THE PUBLIC: By authority of the Interstate Commerce Commission in Finance Docket No. 9736 Dated May 13, 1933, the operation of the railroad between Duncans' Mills and Cazadero will be discontinued on July 31, 1933."

When Train 222 arrived on its last day, the locomotive was detached, run up to the turntable, swung around and returned to couple up with its cars again. It was ready to steam for the last time down Austin Creek to Duncans' Mills.

More than seventy citizens commemorated the day. Some people dressed in black, and others brought flowers. It was said that a miniature locomotive was buried near the tracks. A stone grave marker was placed over it, painted with "No. 23—DIED July 31st 1933."

The *Santa Rosa Republican* printed in its July 31 edition: "Train 222 visited the Sonoma county resort area this morning and returned during the afternoon as train 223 for the last time. The agency will be terminated as soon as the books can be closed."

On August 2, the *Press Democrat* printed:

On Monday local residents including some who had seen the advent of the train here, were at the depot to see it depart. A great assembly of people with music and merry making and staging a mock funeral gave a send off to "old 23" which went whistling and clanging down through the canyon answering the cheers of the crowd. The 9 miles of road between Duncans and Cazadero has been discontinued.

PART II: GUERNEVILLE, 1935

Two years and two months after the last run from Cazadero by Train 223, the Guerneville branch of the Northwestern Pacific Railroad was still in monetary trouble, just like its former Cazadero branch. The Depression was still ruling supreme with everybody's finances, corporation and citizen alike.

Fifty-nine years after the first train pulled into Guerneville, the closing of an era was a very big occasion—the settlements along the river had yearned for a railroad for years. As reported in the *Healdsburg Flag* on March 5, 1877:

> *The completion of the railroad is now an assured fact, and on Saturday, Feb. 24, the cars steamed into town for the first time. They were greeted with a salute from the anvils, and blasts from the mill whistle, to which the engine responded. It was a general holiday in town, and nearly everyone was out to see that the long and anxiously looked for train was no illusion. The track is laid nearly to the creek, and Polly Ann Street* [known today as Main Street] *is fast becoming a network of rails, side tracks, switches and the like.*

The branch line was a moneymaker. The amount of lumber being shipped over the line was second only to Eureka in Humboldt County. When the lumber business waned in the 1910s, tourism took up the slack in the slight slump of economics of the area. But the advent of autos and the Depression took their toll on the NWPRR.

Between Fulton and Forestville, the land was, as now, agriculture for a little over seven miles. From Forestville to Duncans' Mills, it was all resorts. It had a resident population of about four thousand in 1935.

The freight tonnage originating from the line was rapidly declining. During the years 1930 to 1934, the tonnage numbers were respectively 59,500; 44,656; 27,863; 20,998; and 19,588. The passenger numbers for the same time period were 56,585; 51,443; 37,186; 23,961; and 27,509. But all these statistics were converted into money. What was the bottom line of the ledger showing? The operating costs for the five years were $300,884. The income from both passenger and freight was $114,008. This equaled a net loss of $186,876.

The railroad was up against mathematics: diminishing income minus increasing expenses equals abandonment. On July 13, 1935, NWPRR management applied to the ICC for permission to abandon the Guerneville branch from Fulton to Duncans' Mills, approximately twenty-three miles.

Included were all the sidings, spurs, bridges, etc. For two months, the ICC reviewed the NWPRR petition with its financial evidence. As a result, the request was granted on September 26, 1935. The railroad would cease operation on November 15, 1935.

The river community had six weeks to prepare for the "Date of Demise," two weeks less than the people of Cazadero had for their event. But the six weeks to plan were put to good use. The anxiously awaited day arrived—maybe too soon for most. The train was normally called Train 201/202 on its regular daily run and had one passenger car and one baggage car. But the company declared it this day as "Extra 108." Engine 108 appeared rumbling along with baggage car 608 and three coaches, 77, 79 and 86.

The crew consisted of conductor H.H. Johnson, engineer William Burns, fireman G.C. Neighbors, head brakeman E.I. Berry and rear brakeman G.H. Lamb. The first passengers on board were railroad and local officials. Along the line, more passengers boarded—a few here, a few there, picked up for the last ride.

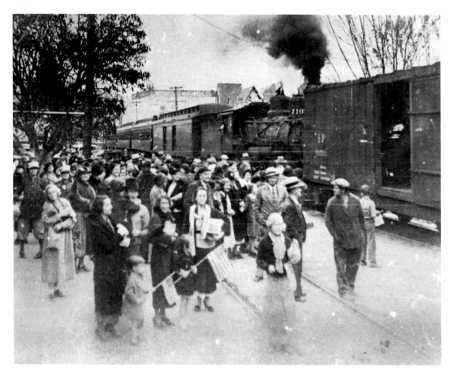

November 14, 1935: the last train to Duncans' Mills arrives in Guerneville with engine X108 at the head. *Courtesy of John C. Schubert Collection.*

The train pulled into Guerneville with a large crowd waiting for it, reminiscent of the vacationers during the heydays of the '20s. Scores climbed on, with women's clubs, civic groups, businessmen and kids going along "just for the fun of it."

It was a declared holiday. A makeshift band banged and blared away at the station. A banner was hung up alongside the last coach: "THE LAST ROUND-UP." A double wreath made by Mrs. J.J. Gambetta and Mrs. K.J. Neeley was hung on the last vestibule.

Pathe News Film Company was supposed to cover the event but was a no-show. Frank Gori, local photographer and amateur movie producer, was also supposed to record the happenings but couldn't, so he gave quick instructions to Ras Jensen, a local electrician, how to work his camera. The results, a ten-minute-long film, left much to be desired, but to see X108 pulling into Guerneville down Main Street is a real thrill. This film has been duplicated on video and is currently in possession of the Sonoma County Library.

The train headed out of town, picking up more passengers at Guernewood Park. The cars arrived at Monte Rio with two hundred and more aboard; the baggage car was opened up for more. More people boarded at Villa Grande.

A basket lunch was served at Duncans' Mills—to supplement the various drinks, fermented or not, brought by the revelers. People, such as Marjorie Pedroia, Red Pool and Mrs. Hembree, climbed on the locomotive for photos. Some got drunk.

Some brought out shotguns and shot holes in the overcast to let sunlight in. Music and singing were the order of the hour. One popular song was "Good-bye, My Lover, Good-bye."

In the meantime, Engineer Burns dropped the passenger coaches, spun around on the turntable and picked up a couple of boxcars. Then the coaches were hooked up again behind the boxcars. The train was ready to make the last trip over the rails.

It was 1:38 p.m. Conductor Johnson looked at his watch and called out, "All aboard!" People climbed, stumbled or were assisted aboard. At 1:40 p.m., up in the engine cab, Burns gave two blasts on the baritone whistle, slowly released the train brakes and eased the throttle, taking up the slack between the cars—banging the couplers. The cars creaked and groaned as they slowly went over the Duncans' Mills bridge.

People lined the tracks at Villa Grande, waving their last salute. The train rolled along with its monotonous clickety-clack, clickety-clack. It rumbled

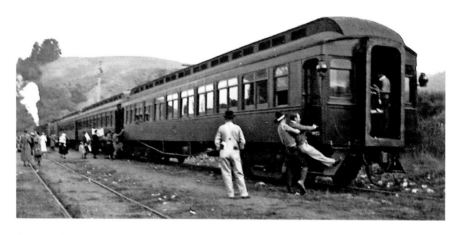

Some had just a little too much to drink. *Courtesy of NWPRRHS Nervo collection #90.003.0024.*

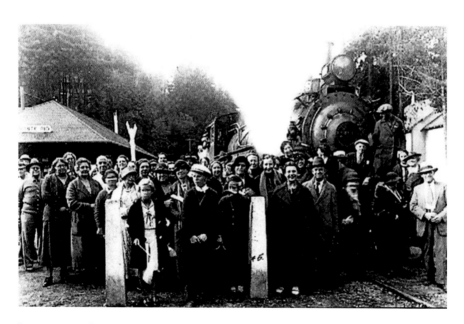

Just one more picture, Monte Rio. *Courtesy of Jane Barry.*

its way into Monte Rio with a crowd waiting for it. Upon arrival, locals gathered around for one last photo at the station.

It was 1:55 p.m. Burns gave two whistles and shoved off, minus two passengers. Charley Peck and Jack Brown were wrestling with inebriation.

The town's fire engine wailed farewell with its siren as Burns slowly rolled over the Dutch Bill trestle. Train X108 chugged its way over the Northwood Bridge, on past Russian River Heights, Montesano, Vacation Beach and Guernewood Park.

The celebration arrived in Guerneville much subdued—the end of the last ride for most on the train. People dismounted, and at 2:20 p.m., Burns repeated his ceremony with two whistles, releasing the brakes, and slowly pulled out of town.

There were a few tears and lumps in the throats as memories were tucked away. Burns didn't help any by hanging on the whistle cord until he was halfway to Rio Nido, the deep sound echoing off the mountain sides and rolling down the river around the bends…fading, and then, gone…

Chapter 10

LAND HO!

Shipwrecks Along the Sonoma Coast

There have been many shipwrecks on the Sonoma coast, from Estero Americano to Gualala River, some forty-four-plus miles of shoreline. From 1860 to the present day, there have been at least fifty-two ships that literally arrived unexpectedly on our shores. These were not small fishing craft or pleasure boats but rather commercial—freight and passenger—*ships*. Presented here are ten of the more interesting tales.

The earliest known wreck was of the schooner *Bianca* out of its home port of San Francisco. It was captained by Steven Williams. On December 6, 1860, it was overpowered by a strong winter storm and driven ashore at Gerstle Cove near Salt Point. There, the vessel broke apart in its final resting place.

Then there was the *Sovereign*, a two-masted schooner with Captain Ross at the command, which left San Francisco on June 30, 1873. It stopped at Fort Ross and left on the morning of July 1 for Fisk's Mill, just nine miles up the coast. A strong northerly current set in and drifted it down the coastline. There was a thick summer fog, so the captain could not see his location. At 2:00 a.m. on July 2, the *Sovereign* struck the rocks just below Duncan's Landing and came ashore. It was a total wreck, but all hands were saved. The insurance company sold the ship to Alexander Duncan for $200. Duncan promptly salvaged everything possible from it. It was insured for $3,000.

The steamship *Monterey*, built in 1869, was 120 feet long with a beam of 27 feet, its tonnage at 382. Sometime between 1875 and 1880 (no exact date has been found), it was making way under the command of Captain

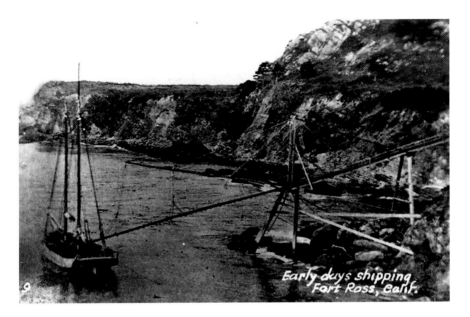

Loading chute, west side of Fort Ross Cove, circa 1900. *Courtesy of John C. Schubert Collection.*

von Helms when it struck a submerged rock one and a half miles southeast of Fort Ross Reef and three-quarters of a mile from shore. For many years after, this hazard was known as "Monterey Rock." It is now marked with a bell buoy painted red. This incident was one of many with this rock.

The *Lammermoor* was built as a clipper ship in 1874 for an English company in Glasgow, Scotland. Its dimensions were 240 feet long, 40-foot beam, 23-foot depth, with a cargo capacity of 2,300 tons. It was an iron vessel, rated by Lloyd's of London as a No. 1. A crew of forty-one handled the sails. In April 1882, the *Lammermoor* left Australia with a load of coal bound for San Francisco under the command of Captain J.D. Guthrie. At midnight on June 27, a summer fog covered the California coast. Captain Guthrie misjudged the entrance to the Golden Gate by forty-five miles and ran *Lammermoor* up on Bodega Rock. A gash was admitting seawater faster than the pumps could handle. By sunrise, the stern was down and the main deck was awash—the ship was fast on the rock. Luckily, the sea was calm. Nothing could be done by keeping the crew on board, so Guthrie ordered them to abandon ship. There was ample room for the crew and belongings in the lifeboats. When all personnel were safely ashore, the captain made arrangements for lodgings in San Francisco. Then, crew and

captain returned to Bodega. and the hulk to recover as many salvageable items and effects as possible, which were then removed to San Francisco. The next day, the owners' agents, cargo consignees, salvage experts and underwriters visited the wreck. After surveying the situation on the Rock, the owners decided to take the insurance money and release ownership to the underwriters. The ship was valued at $60,000 and cargo worth $16,000. In turn, the insurance company put it up for bid. There was only one offer: $750 for ship and $80 for the cargo. The hull was left intact right where it wrecked. When the salvage was done, the beachcombers and pickers took over. Anything that could be taken was taken: brass works, tools, chain, rope, etc. A six-inch bore cannon used for holidays at Bodega is rumored to have come from *Lammermoor*.

In 1878, the steamship *Maggie Ross* was built. It had a length of 115 feet, a beam of 32 feet and registered tonnage of 282. The master was Captain Marshall at the time of its grounding in 1892. A great storm hit Northern California on January 1, 1901. Massive flooding of the Russian River occurred from Ukiah down to Jenner; no town or village was safe. Several coastwise ships became local wrecks. The *Iaqua* became a victim of the tempest, being driven on rocks off the Marin coast. Due to this same storm, Fort Ross was the scene of another shipwreck, the *Eppinger*.

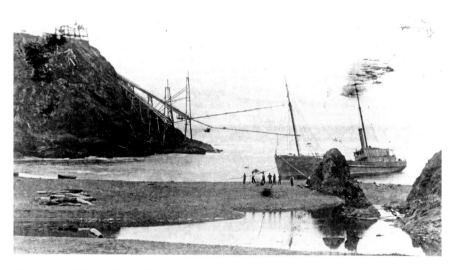

The wreck of *Maggie Ross* at Rule's Landing, 1892. This is now known as Russian Gulch. *Courtesy of Sonoma County Library, call #29361.*

The *J. Eppinger* was built in San Francisco in 1887 as a schooner and registered at 146 tons. It was owned by H.A. Richardson of Stewart's Point. The schooner left San Francisco on December 30. It arrived at Fort Ross on January 1 to take on a load of wool, but strong south winds caused Captain Jensen to stand off from the wharf and anchor as well as possible in the cove to load the following day. The next morning arrived with stronger winds and rougher seas with increasing intensity. People came down to the beach several times during the day to see if the crew wished to be assisted ashore. No attempt was made by the sailors, and by noon, the ocean was too rough for them to come ashore if they wanted to. At eight o'clock that night, through the sounds of the roaring ocean and howling winds, shouts were heard calling for help. The alarm was spread. George and Carlos Call, with a Mr. Walker, rushed to the rocky beach and could make out the *Eppinger*. The schooner's lines had parted, and the furious waves had carried it toward the shore. There it was tossed and rolled on the rocks. The crew was trying to throw a line ashore, but the distance was too great. Carlos Call quickly tied a rope around his body and plunged into the surf. He got the end of the line the sailors were throwing and was pulled back to shore. The line could not be made fast, as the schooner was rolling wildly. So, with more people arriving at the beach, all hands held on the shore end. By this method, the lifeline could move with the ship as it rolled. All six crewmen and the captain were rescued. By the next morning, the vessel was completely destroyed. Large pieces of wreckage washed back and forth and pounded the wharf to pieces.

It was a couple of months after the 1906 earthquake when the *Volunteer* got in trouble. This three-masted schooner (some say four-masted) was built in 1887. Its basic statistics were beam, 40 feet; length, 128.5 feet; tonnage, 529. On June 4, 1906, Captain Robert Bressen had *Volunteer*'s bow pointed for Coos Bay, Oregon. On board were his wife, their four children, two officers and six crewmen. A little before midnight, the *Volunteer* came to an abrupt halt. It had rammed the rocks off Bodega Head. Quickly, the captain had his wife and children in the ship's lifeboat. While heading to the shore, the boat capsized; two sons were drowned. On shore, citizens had come to the rescue. Two men managed to get a line on board and saved five of the crew, while the sixth crewman went under. Captain Bressen stayed aboard until he had to abandon ship. The schooner was finally pounded to pieces.

Bodega Bay (not Bodega Harbor) and Bodega Head were "accidentally" visited a number of times by ships—both steamers and sailers. The next surprised visitor to the Head was the steam schooner *Newburg*. *Newburg* was

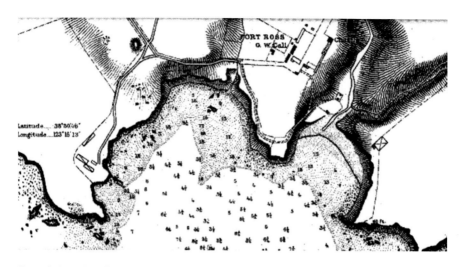

Part of chart: Fort Ross Cove, 1905. The loading chute for lumber and other cargo is at the end of the road to the left on chart. *Courtesy of the Historical Map & Chart Collection/NOAA.*

The 1942 survey map of Bodega Head, including Bodega Rock, Bodega Head, Bodega Bay and Bodega Harbor. *Courtesy of USGS.*

built in 1898 at 450 tons. It was eight o'clock in the morning on October 8, 1918. The seas were rough, and the *Newburg* was driven ashore on the north beach of Bodega Bay (today's Doran Beach). Word was sent to San Francisco for tugs, but as of six o'clock that evening, none had arrived. In the meantime, the schooner was being driven up higher on the sandy beach and had begun to break up. The rudder and keel were washed ashore. The crew stayed aboard that night, hoping the tugs would arrive by flood tide that night, thus saving the vessel. None came to the rescue. *Newburg* was high and dry the next morning—almost a total loss. Parts of the cargo and machinery were salvaged.

The *Klamath* was a 1,038-ton steam schooner built in 1910. The ship was crewed by thirty-six men, with Thomas Jamieson their captain. On February 4, 1921, a major storm was raking the Northern California coast, the winds reaching eighty-five miles per hour with gusts up to one hundred. Ships were in great peril. Steamer *Raymond* had engines disabled twenty-one miles at sea off the coast of Eureka. No tugs or other vessels could leave Humboldt Bay to assist it. Steamer *Washington* was overdue at Eureka and missing between there and San Francisco. The *Klamath* was also having its share of trouble. It was heading for Portland in ballast with nineteen passengers, among them four women and an eighteen-month-old baby boy. Like the other two ships mentioned previously, *Klamath* became a victim of the tempest. It was February 6 when it was carried onto the rocks between Stewart's Point and Del Mar landing. The captain ordered full speed astern, but the steamer backed onto other rocks. He sent an "SOS" out and then sent a second message to the RCA station at Bolinas saying two lines were gotten ashore and his aerials were toppling over. The steamers *Alaska*, *Queen* and *Curacao* picked up the SOS. *Curacao*, en route to Eureka, was the closest and went at once to aid the *Klamath*. It stopped off half a mile from shore long enough to determine that no one was aboard. Being unable to assist ship and captain, *Curacao* continued on. The steam schooner *Everett*, en route to San Diego, took *Curacao*'s place and sent a wireless out: "Unable to approach *Klamath* on account of mountainous seas. [Our] deck load in poor shape. Klamath too far away for me to detect any people."

Everett was ordered to stay on location until another ship could relieve it. Aboard *Klamath*, a breeches buoy was rigged to shore to get all to safety. The tradition of "women and children first" was followed. The only problem was getting the baby to safety. It was solved by a crew member who wrapped the boy in blankets and then, placing him in a garbage can and strapping the can on a sailor's back, put sailor and baby into the breeches buoy and hauled

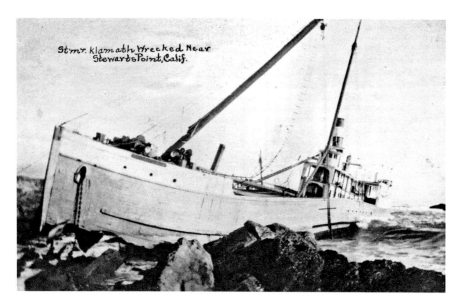

Klamath's true site was just south of Del Mar Point at Sea Ranch. Note the gaping hole in the bow. *Collection of the Richardson family, courtesy of Susan M. Clark.*

The Japanese ship *KenKoKu Maru* in the sandy cove north of Black Point, not Stewart's Point. Its name is misspelled on the photo. *Courtesy of Sonoma County Library, call #34241.*

the breeches buoy to shore. It worked: mission accomplished! All passengers were sent back to San Francisco. The owner, McCormick & Co., was hoping to salvage the vessel, but by February 8, it had broken in two and had four holes in its hull. *Klamath* was a total loss, valued at $175,000.

The *KenKoKu Maru* has two major distinctions with its beaching on April 28, 1951. First, *KenKoKu* was the last ship—not boat—to be beached on the Sonoma coast, and second, it was the first foreign vessel to do so. The ship was the second-largest vessel to come ashore in Sonoma County. *KenKoKu* was heading for San Francisco; following the usual great circle route from Japan, it was steaming south along the coast close to shore. It was 1:00 a.m. There was a driving rainstorm, and as the ship entered a thick fog, Captain Shigeo Fujime, thinking he was opposite the Golden Gate, turned to port. He steered his ship straight into a cove north of Black Point. A few minutes later, the ship was grinding its bottom plates on a shallow reef, running out from the cove's sandy beach. The seas pushed it parallel to the shore. The ship's owners, after viewing the scene, gave themselves a 50-50 chance of saving it. Maritime salvage companies arrived from San Francisco. Waiting for the nor'wester's thirty-knot winds to stop and for high tides, the operation was getting into shape. The *KenKoKu* was resting amid-ship on the rocks. Several major attempts were made to extract it over a period of weeks. Its stern was slowly pulled around to face the sea. Then, by yards, *KenKoKu* was dragged over the shallow reef. The final "Big Pull" came on May 22, nearly a month after arrival. It was freed and taken to San Francisco for repairs. *KenKoKu* returned to the Pacific, but the repairs did not hold, and it sank in the Philippines.

Chapter 11

LICENSED TO DRIVE

The Automobile Comes to Sonoma County

Occasionally, when doing research for an article, I have stumbled across a short news story, advertisement, government bulletin or list that has set me off on a chase to run down some tidbits of information to satisfy the hunger for history. That's what occurred when I was reading, out of curiosity, a 1909 resource entitled *The San Francisco Blue Book—The Fashionable Private Address Directory*. In it was a list seventy-two pages long in fine print that had all the automobiles registered in California.

With the turn of the twentieth century, the Industrial Revolution had matured. The mechanical age was coming on strongly, enough so that the dreamers and tinkerers could put their infant ideas to the test of research and development. The most extensive of today's businesses to come from these beginnings is the automobile. By 1905, auto names included Cadillac, Ford, Olds and Packard, as well as lesser knowns like Toledo, Duryea and Franklin.

Owners of automobiles in California had to register their cars with the California secretary of state, the predecessor of the Department of Motor Vehicles. The state levied a tax on the autos and also assigned them a number. However, the first permanent state license plates to be attached to cars were not issued until 1914. Drivers' licenses were not issued until 1916, although some counties started the process as far back as 1904. For example, in Marin County, Chauncey A. LeBaron, at age twenty-four, was issued license #58 to ambulate about in his Oldsmobile.

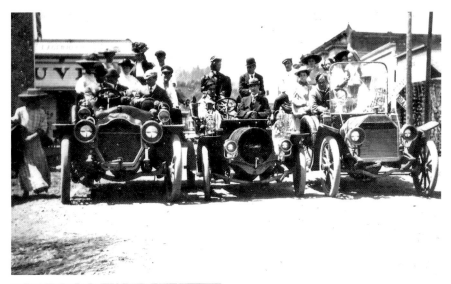

INVEST IN A REO

REO 5-Passenger Touring Car, fully equipped with glass front, speedometer, top and side curtains, demountable rims, nickel trimmed. wheel base 112 inches, 34 inch wheels

PRICE, $1285

SNOW & WATSON, Agts.

Santa Rosa Avenue Sebastopol, California

Above: Lining up the autos in Guerneville, circa 1912. *Left to right*: an EMF, a Franklin and a Pierce. *Courtesy of John C. Schubert Collection.*

Left top: the four-cylinder Reo. *Left middle*: A Reo advertisement from the *Sebastopol Times*, 1911. *Left bottom*: Mrs. H. Pohlman takes second prize at the 1908 Rose Parade in Santa Rosa. *Courtesy Simone Wilson Collection.*

By 1909, there were in excess of eighteen thousand autos registered in the state, an average of one car per 132 people. The state population was 2,377,550. Over 50 percent of the registered autos were located in the Los Angeles/Pasadena area, while some counties had no automobiles registered whatsoever (although Sonoma County was definitely not among them).

In 1909, Sonoma County had a population of 48,400. At the same time, the county had 262 vehicles listed on the state's rolls, or about 1 car for every 108 residents. Naturally, a majority of the registered autos were found in and around local towns. Petaluma had the most, followed by Santa Rosa:

Petaluma	87
Healdsburg	29
Geyserville	11
Sebastopol	6
Santa Rosa	76
Cloverdale	16
Sonoma	10

The remaining twenty-seven autos were sprinkled around the county. While most car owners had only one car, there were several well-to-do families that could afford three or more, including the following:

W.T. Albertson	Healdsburg
C.W. Savage	Santa Rosa
Sam Talmadge	Santa Rosa
H.F. Smith	Petaluma
J. Steiger	Petaluma

Among those families of ninety-five years ago are some recognizable names: Burbank, McNear, Cassin, Crane, Cnopious, Brainard, LeBaron, Passalaqua and Nisson.

Not to be left out, there were eleven ladies with autos. In Santa Rosa, they were Shirley D. Burrie, Mrs. John Cnopious Jr., Mrs. R.C. Rohr and Mrs. H. Pohlman. In Petaluma, they were Mrs. W.H. Pepper and Mrs. M.C. Erikson; in Sebastopol, Mrs. A.E. Fennell and Mrs. S. Turner; in Healdsburg, Mrs. A.W. Scott Jr. and Mrs. J.B. Wainwright; and in Graton, Mrs. B.J. Gambsy.

Some fourteen doctors out of a group of seventy in the county could rattle their way around the countryside on house calls. Of the fourteen, five were in Santa Rosa, four in Petaluma and three in Sonoma.

First license plates. These plates were made of heavy-gauge metal, printed in red with white letters. Later on, they were painted yellow with black lettering. Interestingly, these "porcelain auto tags" were manufactured not in California but at the Ing-Rich Manufacturing Co. in Beaver Falls, Pennsylvania. *Courtesy Gaye LeBaron Collection.*

Driving early automobiles along the Russian River. *From "Motor Touring in California,"* Sunset Magazine, *December 1903. Courtesy of John C. Schubert Collection.*

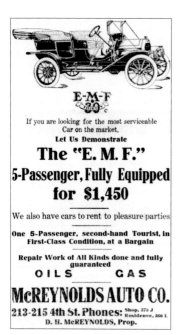

A 1910 newspaper ad for EMT
vehicles for sale in Santa Rosa.
Courtesy of Press Democrat, *August
16, 1910, p. 6.*

No known vehicles were owned by
any government agency. If there were
any emergency vehicles—fire, police,
ambulance—none were registered.

Prior to 1905, pioneer automobile agents
in Sonoma County first started out as cyclery
shops. The earliest in Santa Rosa were
George Schelling's Schelling Cyclery on
Fourth Street and F.J. Wiseman's Santa Rosa
Cyclery on Mendocino Avenue.

Four years later, five more automobile
agents were in business: O.L. Houts in
Santa Rosa, J.A. Brown in Santa Rosa and
Healdsburg, A.L. McFee in Healdsburg,
J.H. Madison in Petaluma and the Sonoma
Garage in Sonoma.

A search reveals that no automakers
of today appeared on the marquees for
Sonoma County businesses during this
period. In Sonoma County in 1909,
Schelling sold Maxwell, Rambler and
Studebaker. Wiseman advertised Reo and
White autos. Houts sold Reos, along with
the Stoddard-Dayton.

Chapter 12

Connecting the Coastline

Jenner's First Bridge

In 1915, over one hundred years ago, the idea was conceived for a bridge near the mouth of the Russian River. The technology of steel spans was already being used with the railroad industry, as in the case of the Hacienda Bridge built in 1914. For whatever the reason, whether political or economical, the proposed bridge would not be constructed.

Fourteen years later, the need for a span really became evident. Motorists traveling along the Sonoma coast would reach the river and a traffic choke point. Traffic was badly congested at Markham's ferry, the only means of crossing the Russian River. Many motorists would turn around and return the way they came, "due to the long waits caused by the antiquated county carrier." Waits could be for several hours. It wasn't until 1930 that the thought of constructing a bridge was revisited and reached a final conclusion: build it.

The bridge would be part of the Shoreline Highway, which would run from San Francisco in the south to Legget in the north. Our present-day Pacific Coast Highway—State Highway 1—wouldn't be designated until 1937, when it would become the state's first complete north–south highway.

The governmental body with jurisdiction over this construction was a highway district, District 16, created in 1930. It was composed of Marin, Sonoma, Mendocino and San Francisco Counties, with a representative from each. The building of the bridge was financed by the four counties plus the state. The preliminary cost estimate by the district was $190,000. Sonoma County's share was set at $85,000 by the county supervisors. The

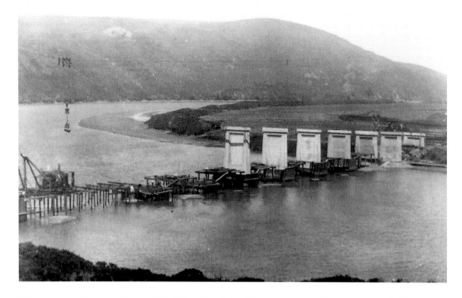

The construction site, June 1931. The view is looking west, downriver. *Courtesy of John C. Schubert Collection.*

district called for bids to be submitted by December 23. Two were offered; Rocca & Caletti of San Rafael presented theirs of $173,000, while Fred J. Maurer & Sons put their bid at $184,000. As soon as they were chosen, Rocca & Caletti started their preliminary surveys of the site. The contract between county and company was signed on January 9, 1931. The deadline for the finished bridge was August 15, 1931.

The first weeks were used to grade, excavate and prepare the sites for the road approach piers. Project superintendents were inspecting local forests for timbers to be cut and used as framework, forms, sheds and other necessary components. By mid-February, a donkey engine, fuel tanks and other machinery were on site. The cofferdams would not be built until after the threat of winter's high water had passed.

In the meantime, the crew of fifteen men, nearly all from Sonoma County, was busy. Two high-line towers on opposite banks were erected. The south tower on the high bank was 70 feet tall, while the north tower was 120 tall, putting the tops at equal heights. A cable 1,100 feet long was strung between them. The cable had a clearance of 120 feet above the river, and once it was in place, the false-work was started, using a tram with a fifteen-ton capacity to carry structural steel, timbers, concrete and other parts for the bridge. The

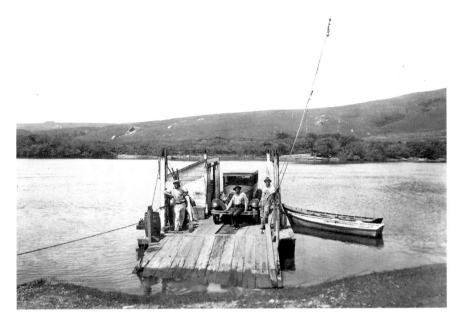

The Jenner/Markham Ferry, circa 1930. The capacity was three cars per trip (view is looking south toward Willow Creek). *Courtesy of Sue Girot Collection.*

grading on the 1,600-foot long north bank approach was done by March 12, taking nine days to complete. This was duplicated on the south side.

Now that the rainy season had passed, forty more men were added to the construction gang. The steel cofferdams were in place and the steel piles driven by mid-April so that the nine pier foundations could be poured below the level of the river. These were sixty feet apart. After that, work moved rapidly. In the middle of May, three piers, reinforced with rebar (as all would be), had been completed, two bases poured and the pile footing for the sixth was underway. The remaining three would be completed within a month.

Steel trusses and girders were concurrently being fabricated in Oakland by Pacific Coast Engineering Cal. The *Press Democrat* reported in its June 2 edition, "Huge trucks and trailers laden with the heavy steel work have been passing through Santa Rosa for several days."

Imagine what the roads were like in the county eighty-six years ago. There was no freeway. The highway (today known as Santa Rosa and Mendocino Avenues) went through the middle of Santa Rosa.

July arrived. The piers were completed and girders were in place spanning the piers. Now the forms for the road deck on the approaches could be laid out and more concrete could be poured. Next was the

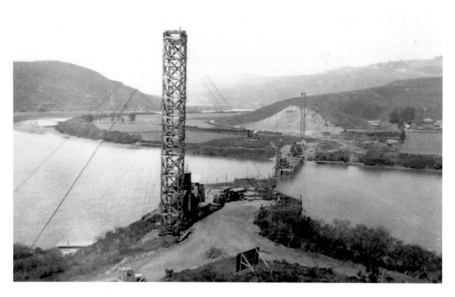

Cable towers to transport material and concrete to the pier and roadbed forms. The view is looking northwest. *Courtesy of Elenor Twohy.*

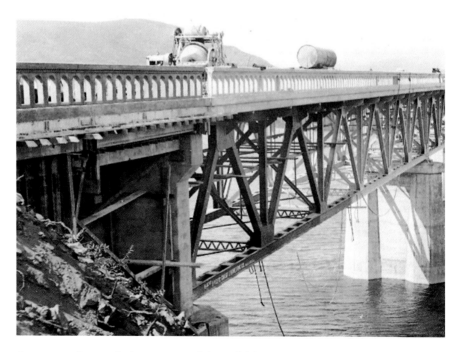

A concrete mixer on the last segment of the unfinished roadbed. Note the form cribbing under the bridge approach. This is the probable area where Baldwin fell from the bridge into the river. *Photo by Rhea, Monte Rio. Courtesy of John C. Schubert Collection.*

construction of the two main piers in the river and the south pier on the steep embankment. Besides being farther apart, these piers were shorter but more massive than the others. They supported the large steel trusses of 145-foot spans. These trusses were to carry the weight of the concrete roadbed plus the added weight of automobiles and trucks. This total of twelve piers made the bridge 900 feet long. The pouring of the roadbed was next, starting August 1.

On August 13, the first and apparently the only serious accident occurred. While working on the bridge frame, Frank Baldwin of Jenner lost his footing and fell forty feet into the river. He couldn't orient himself in the air and consequently hit the water on his right side, breaking three ribs and a leg. Fellow workers pulled him from the river and rushed him to Dr. George W. Burgess in Guerneville. Later that same day, he was taken to Mary Jesse Hospital in Santa Rosa. None of his injuries was considered critical.

In mid-August, the steel work was complete and approximately half of the concrete roadbed had been poured. In September, nearly all the major work was done, with only the finishing touches to the structure and the cleaning up of the site left to do for the remainder of the month.

With construction coming to an end, the dedication and program were being selected and organized. The dedication date was Sunday, October 4. Hundreds were expected to be at the bridge-opening celebration. Announcements were given over two San Francisco radio stations. Two days before the celebration, the predicted attendance was increased to two thousand. That prediction wasn't even close. More than seven thousand people showed up! The dedication program opened with music supplied by the Santa Rosa Panthers and Fort Bragg Eagles high school bands. The master of ceremonies was Victor Canepa, of the San Francisco Board of Supervisors. He was followed by San Francisco attorney Walter McGaughey, who gave the address of welcome. McGaughey was followed with two-minute speeches given by Clarence F. Lea, U.S. congressman of Santa Rosa; Arthur H. Breed, president of the state senate; Herbert H. Slater, state senator of Santa Rosa; Hubert Scudder, state assemblyman; Angelo Rossi, mayor of San Francisco; William Deysher, supervisor of Marin County; Ed Enzenauer, supervisor of Sonoma County; Frank P. Doyle, director of Golden Gate Bridge and Highway District; Tim Reardon, state highway commission; Fred Suhs, president of the Shoreline Highway Association; H. Ridgeway, president of the Redwood Empire Association; and Stanley Jones, president of the Santa Rosa Chamber of Commerce.

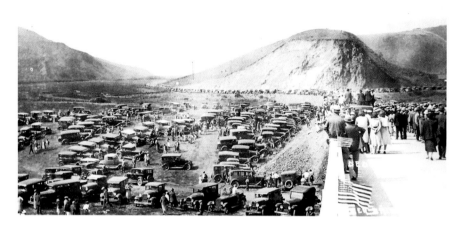

The dedication of the bridge with more than seven thousand people. *Courtesy of John C. Schubert Collection.*

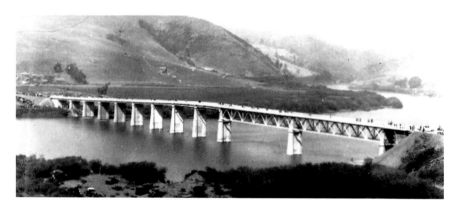

The finished Jenner Bridge, October 4, 1931. Note the pedestrians on the bridge. *Courtesy of John C., Schubert Collection.*

The dedication was completed with the unveiling of a brass plaque on the north end of the new bridge, and a bottle of grape juice was broken on the railing by June Osborn of Sebastopol.

The reason for such a big celebration (don't forget Fort Bragg was there) and all the politicos appearing at this event (they weren't there just for their own campaign purposes) was due to this new accessibility and subsequent

increase of Northern California coast economy and tourism. State senator Herbert Slater helped form the Sonoma Coast Beach State Park project in 1930 and 1931. And then along came the creation of the Shoreline Highway, known as State Highway 1. It was preceded by the Redwood Empire Association designating the future State Highway 101 the "Redwood Highway." The Jenner Bridge project helped propel this development.

And just how important was the bridge? The dedication photos are self-evident—they prove its importance to the future of the coast and river economy and development.

THE END OF AN ERA: GOODBYE TO MARKHAM'S FERRY

And what of the old ferry? In 1891, Alex Cuthill came to California from Scotland. He was appointed operator of the Markham/Jenner ferry by the county starting in 1918. He was sixty-four at the time and captained the boat for thirteen years. Cuthill worked twelve hours a day (occasionally longer) hauling automobiles and sometimes wagons back and forth across the water. He was known as the "Autocrat of the River."

In the summer of 1930, Cuthill was working on the single-cylinder engine when he slipped on the wet floor in the engine shed and bumped his head on the flywheel. He didn't think much of it at the time, but it didn't heal properly. An infection set in, causing a serious glandular problem around his ear. He didn't want to leave his post due to the injury, saying he was the only one capable of keeping the double-ended water craft running. He worked with the injury for the following year until he could no longer rise out of bed. He was taken to Santa Rosa on May 30 and passed on eight days later. Cuthill's son, George, filled in as operator for three months until the bridge opened for traffic.

During the celebration, a big attention-getter after the speeches was the torching of the old ferry.

EPILOGUE

The structure's proximity to the ocean contributed to its eventual deterioration, and no amount of painting could arrest the rusting of steel members and the spauling of concrete piers. The much-celebrated bridge

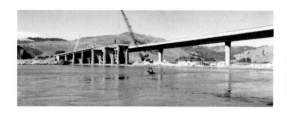

The razing of the 1931 Jenner Bridge alongside the new 1984 bridge. *Courtesy John C. Schubert Collection.*

lasted fifty-three years before it was replaced in 1984 by the modern bridge we see today.

At the dedication of the 1984 bridge, approximately twenty-four people were in attendance.

BIBLIOGRAPHY

Newspapers

Mendocino Democrat, Ukiah, CA, August 11–November 23, 1871.

Russian River Flag, Healdsburg, CA, February 23–November 16, 1871; May 11–June 29, 1876.

Santa Rosa Daily Democrat, Santa Rosa, CA, May 20–July 12, 1876.

Santa Rosa Press Democrat, Santa Rosa, CA, December 1930–October 1931.

Santa Rosa Times, Santa Rosa, CA, May 11–July 13, 1876.

Sonoma Democrat, Santa Rosa, CA, December 30, 1871; January 20–April 27, 1872; May 20–July 15, 1876.

Journals/Periodicals

Barrett, S.A. "Ethnogeography of Pomo and Neighboring Indians." *University of California Publications in American Archaeology and Ethnology* 6 (1908): 265–66.

———. "Material Aspects of Pomo Culture." *Bulletin of the Public Museum of the City of Milwaukee* 20 (1952): 187–91, 417.

Baumhoff, Marin A. "Ecological Determinants of Aboriginal California Populations." *University of California Publications in American Archaeology and Ethnology* (1963): 231.

Chernykh, E.L. "Agriculture of Upper California: A Long Lost Account of Farming in California as Recorded by a Russian Observer at Fort Ross in 1841." *Pacific Historian* 11, no. 1 (1967): 26.

Cutter, Donald C. "California, Training Ground for Spanish Naval Heroes." *California Historical Society Quarterly* (June 1961): 115, 116.

De La Sierra, Benito, A.J. Baker and Henry R. Wagner. "Fray Benito De La Sierra's Account of the Hezeta Expedition to the Northwest Coast in 1775." *California Historical Society Quarterly* 9, no. 3 (1930): 201–42.

Driver, Harold E. "Wappo Ethnography." *University of California Publications in American Archaeology and Ethnology* (1936): 213–14.

Ferguson, Ruby A. "The Historical Development of the Russian River Valley 1579–1865." Master's thesis, University of California–Berkeley, 1925.

Gifford, Edward Winslow. "Ethnographic Notes on the Southwestern Pomo." *University of California Anthropological Records* (1967): 3, 27, 40, 43–44.

Kroeber, Alfred Louis. "Papers on California Ethnography." University of California Archaeological Research Facility, 1970, 105.

Loeb, E.M. "Pomo Folkways." *University of California Publications in American Archaeology and Ethnology* (1926): 20, 183, 200, 202.

Merriam, C. Hart. "Ethnographic Notes on California Indian Tribes." *University of California Archaological Survey* (1967): 74–75.

Oswalt, Robert L. "Kashaya Texts." *University of California Publications in Linguistics* 36 (1964): 247, 253, 277.

Stewart, Omer C. *Notes on Pomo Ethnogeography* 40, no. 2 (1943): 29–62.

Books

Bancroft, Hubert H. *History of Alaska*. San Francisco: History Company, 1886, 78.

———. *History of British Columbia*. San Francisco: History Company, 1887, 197, 210, 217–21, 228–29, 287.

———. *History of California*. Vol. 1. San Francisco: History Company, 1884, 57, 80–81, 95, 224, 240–41, 242, 297, 299, 329, 509–10, 512, 513, 516, 518.

———. *History of California*. Vol. 2. San Francisco: History Company, 1885, 299, 498.

———. *History of California*. Vol. 3. San Francisco: History Company, 1885, 256–57, 274, 360.

———. *History of California*. Vol. 4. San Francisco: History Company, 1886, 71–73.

———. *History of California*. Vol. 5. San Francisco: History Company, 1887, 668.

————. *History of the Northwest Coast.* Vol. 1. San Francisco: History Company, 1884, 11, 15.

Beals, Herbert K. *For Honor and Country: The Diary of Bruno de Hezeta.* Portland, OR: Western Imprints, the Press of the Oregon Historical Society, 1985, 52, 62–65, 79, 156.

Bodega y Quadra, Juan. *Collections of Diaries and Narrations for the History of the Voyages and Discoveries III...Bodega y Quadra 1775.* Madrid, SP: Instituto Historico de Marina, 1943.

Colnett, Captain James. *Journal of Captain James Colnett, Aboard the Argonaut.* Edited by F.W. Howay. Toronto: Champlain Society, 1940, 58–132, 308–18.

Darms, H.A. *Portfolio of Santa Rosa and Vicinity.* Santa Rosa, CA: Press Democrat, 1909.

Denton, V.L. *The Far West Coast.* Toronto: J.M. Denton & Sons, Ltd., 1924, 270–71.

Dickinson, A. Bray, and Roy Graves. *Narrow Gauge to the Redwoods.* 2nd ed. Glendale, CA: Trans-Angle Books, 1970.

Galvin, John, ed. *A Journal of Exploration: Fr. Campa's Diary of 1775.* San Francisco: John Howell Books, 1964, 64.

Kennedy, Mary Jean. *Culture Contact and Acculturation of the Southwestern Pomo.* N.p.: California Indian Library Collections, 1955, 41.

Kingsbury Directory of Santa Rosa and Sonoma County. Santa Rosa, CA: Press Democrat, 1905.

Kroeber, Alfred Louis. *Handbook of the Indians of California.* New York City: Dover Publications, 1925, 219–20, 233.

LeBaron, Gaye, and Joann Mitchell. *Santa Rosa: A Twentieth Century Town.* Santa Rosa, CA: Historia Ltd., 1993.

Meany, Edward S. *Vancouver's Discovery of Puget Sound.* Portland, OR: Binfords & Mort, 1949, 52–55, 59, 60, 303–4, 311, 317, 319–20, 324, 334.

Mitchell, S. Augustus. *Mitchell's School Atlas.* Philadelphia: Thomas, Cowperthwait & Co., 1851.

Mourelle, Don Francisco. *Journal of the Voyage in 1775.* London: Daines Barrington, 1781; repr., San Francisco, n.d.

Powers, Stephen. *Tribes of California.* Washington, D.C.: Government Printing Office, 1877, 174, 178, 180.

Revere, Joseph Warren. *Naval Duty in California.* N.p.: Biobooks, 1947, 116.

Stindt, Fred. *Trains to the Russian River.* Santa Rosa, CA: Pacific Coast Chapter R&LHS, 1974.

Thomson, Thomas H. *Historical Atlas of Sonoma County.* Santa Rosa, CA, 1877.

Thurman, Michael E. "Juan Bodega y Quadra and the Spanish Retreat from Nootka." In *Reflections of Western Historians*, edited by John D. Cabroll, 50–54, 59, 60, 62. Tucson: University of Arizona Press, 1969.

———. *The Naval Department of San Blas*. Glendale, CA: Arthur H. Clark Co., 1967, 149, 160, 170, 172, 174–78, 184, 234, 236, 251, 257–300, 311, 313, 314.

Tuomey, Honoria. *History of Sonoma County, California*. Vol. 1. Chicago: S.J. Clarke Publishing Company, 1926, 119–20.

County Offices

California Department of Transportation. Plans and elevations for Bridge #20-195.

Sonoma County Coroner's Office. No title. [Inquest over the body of James Rowland] File dated 1876. Microfilm.

Sonoma County Deparment of Transportation. Plans and elevations for Bridge #20-195.

Sonoma County Recorder's Office, Book 44 Maps, page 183.

Sonoma County Recorder's Office, Grand Jury Report, May–July term 1876. Microfilm.

Sonoma County Recorder's Office, Probate File, Estate of James Rowland, No. 816. Microfilm.

Sonoma County Recorder's Office, Register of Deaths, Book 41.

Persons/Interviews

Barry, Jane, president of the Russian River Historical Society.

Berry, Jim, Cazadero historian.

Campagna, Gus, Northwestern Pacific Railroad Historical Society archivist.

Santos, Kathryn, California State Railroad Museum archivist.

Miscellaneous

District Court. Seventh District Judgement/Conviction dated February 26, 1872. Governor of California Pardon File, California State Archives.

Ethnograph 1089. University of California–Berkeley Archeological Research Facility.

Henley, Barclay. Affidavit dated February 26, 1872, Re: prisoner #5156. Governor of California Pardon File, California State Archives.

People v. John Houx, case #570. Sonoma County Superior Court records, Santa Rosa, CA.

People v. W.A. Samsel, case #664. Sonoma County Superior Court records, Santa Rosa, CA.

San Quentin file, prisoner #5093, California State Archives.

San Quentin file, prisoner #5156, California State Archives.

San Quentin file, prisoner #5157, California State Archives.

Thompson, Thos. H. *Map of Sonoma County, California*. Oakland, CA: Thos H. Thompson & Co., 1877.

Valentine, Ino J., of Wells Fargo and Co. Letter dated June 26, 1872; report of Hume & Thacker, Governor of California Pardon File, California State Archives 1885, 11–12.

INDEX

ABOUT THE AUTHORS

JOHN C. SCHUBERT was born in 1938 in San Francisco. During his childhood, although living in various Northern and Southern California communities during the winter, he spent his summers on the Guerneville property his grandfather acquired in 1920. He has lived permanently in the Guerneville area since 1956.

The author received a BA degree in anthropology at Sonoma State University. He has been known as the Russian River historian since 1960 and has written for several Guerneville newspapers with his column "Stumptown Stories." He has received numerous literary awards for his poetry and historical articles. He worked as a Sonoma County deputy sheriff for thirty-nine years, which, due to his proximity to the county seat, helped him to acquire (and in some cases save) copious amounts of historical data. John has served on numerous boards, including the Sonoma County Historical Society (past president), Russian River Historical Society and the Sonoma County Library. He is a former U.S. Marine. He has three sons: Keith, Hilmar and Preston; and five grandchildren: Jasmine, Sabrina, Johnna, Heather and Doran. He resides in the redwood-bedecked town of Guerneville, California, with Sarah, his companion of thirty-three years.

Born in 1985 in the Bay Area peninsula and raised in her family's summer cabin just east of Guerneville, VALERIE A. MUNTHE is no stranger to the wilderness of the Russian River Valley and the pull of its history. From a young age, history has always captured her attention. In 2009, she and John

began their first manuscript, *Russian River: Then & Now*, which marked the beginning of her apprenticeship of local history. Since then, she has worked on three manuscripts about local history (*Stumptown Stories: Tales of the Russian River*, *Guerneville Early Days* and *Hidden Histories of Sonoma County*) as coauthor and copyeditor/contributor. She has also served on the board of the Russian River Historical Society as secretary and calendar designer. Her accolades consist of being an ardent volunteer for her community, having worked with groups such as the Friends of Stumptown, Friends of the Russian River Skatepark and Russian River Historical Society. She has received the highest honor of sainthood by the Russian River Sisters of Perpetual Indulgence. A graduate of the Santa Rosa Junior College, she is also a writer of things nonhistorical on her blog, My Gal Val; an artist of multiple mediums, including black-and-white film photography, painting and graphics design; and a hostess at one of Russian River's finest resorts. When she isn't glued to her computer screen, she's raising her three children, Atreyu, Jadziah and Stella, with Jesse, her husband of fifteen years, in the hills of Monte Rio.

Visit us at
www.historypress.net